A–Z

OF

BEVERLEY

PLACES - PEOPLE - HISTORY

Paul Chrystal

AMBERLEY

'a very fine town for its size. It's preferable to any town I saw except for Nottingham'
Celia Fiennes, *Through England on a Side Saddle in the Time of William and Mary* (1888)

'among the finest of England's small country towns'
Sir Nikolaus Pevsner, *The Buildings of England – Yorkshire: York and the East Riding* (1995

'this little town ... so little touched by the ravages of the past three decades has survived
with such good grace'
The Independent (9 April, 1994)

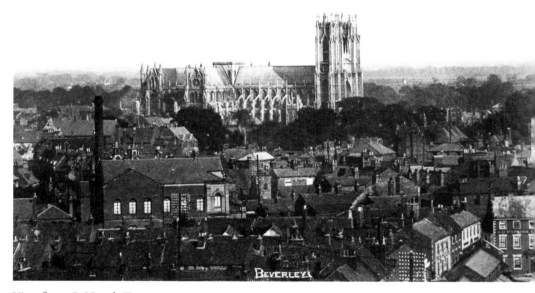

View from St Mary's Tower, 1909.

First published 2019

Amberley Publishing
The Hill, Stroud, Gloucestershire, GL5 4EP
www.amberley-books.com

Copyright © Paul Chrystal, 2019

The right of Paul Chrystal to be identified as
the Author of this work has been asserted in
accordance with the Copyrights, Designs and
Patents Act 1988.

ISBN 978 1 4456 8698 1 (print)
ISBN 978 1 4456 8699 8 (ebook)

British Library Cataloguing in Publication Data.
A catalogue record for this book is available
from the British Library.

Origination by Amberley Publishing.
Printed in Great Britain.

Contents

Introduction

The aim of this book is to shed light on aspects of the history and heritage of this fascinating market town, organised alphabetically.

In the Middle Ages, Beverley was at the centre of England's wool industry, making it one of the biggest and wealthiest towns in the country, with a port that was just as busy. Wool aside, industries have ranged from shipbuilding and steel to tanning and motor parts. Beverley, of course, has always been an important ecclesiastical centre with two of the finest religious buildings in the UK: the Beverley Minster and St Mary's.

Do you want to know the connection between Beverley and Jack the Ripper; the town's connection to the Cod Wars with Iceland; how it was a sanctuary town and why Charles I spent an enforced three-week holiday in a guest house in North Bar Within; the part Beverley's shipbuilders played in the battle against German First World War submarines; how Beverley put the fear of god in William the Conqueror; how St John struck his henchman, Toustain, down in the Minster; how Beverley passed an industrial pollution law in 1461; learn about Beverley's moving First World War street shrines; why 'the closest you'll get to time travel in any pub in Britain' when you drink in Nellies; Beverley's role in the Pigrimage of Grace in defiance of

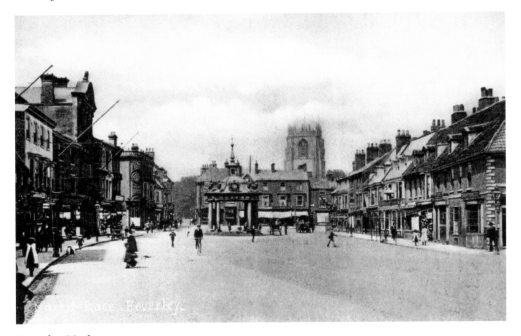

Saturday Market.

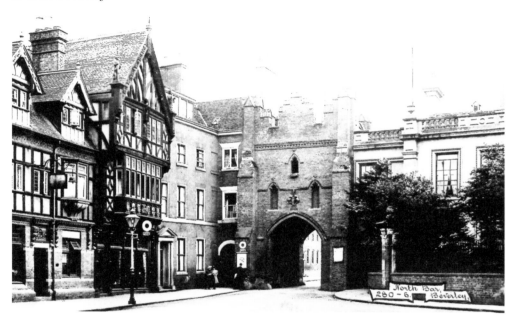

The famous North Bar.

Henry VIII; the work of the Beverley Emigration Society; and how Whitley bombers from RAF Leconfield were the first British aircraft to penetrate German airspace in the Second World War. If you want the answers to these questions, and many more besides, then read on...

Altisidora

The Altisidora pub now occupies a number of adjacent fifteenth- and sixteenth-century buildings in Bishop Burton, and was originally owned by Hull Brewery. The name commemorates the 1813 Doncaster St Leger winner. It was in that year that the landlord staked everything he had, plus the inn, on Altisidora winning. Before this the pub had been named both the Horse and Jockey and The Evander – another racehorse.

According to the pub's website,

> Altisidora (the horse) was owned by the local squire, Richard Watts and was trained by 'Old' Tommy Sykes at his stables near Malton. The horse was a chestnut filly, born in 1810 and as a three-year-old won two out of her first three races before embarking on a second season which saw her win the St. Leger, beating fourteen other horses and this after no less than ten false starts.

She was unbeaten for the next two seasons, winning three races, including the St Leger at Doncaster as a three-year-old and four as a four-year-old in 1814. In her

The Altisidora in her early days.

final season she won four of her eight races, including a Great Subscription Purse at York, the Fitzwilliam Stakes at Doncaster and a King's Plate at Richmond.

The Great Subscription Purses were a series of flat horse races run at York, usually over a distance of 4 miles, that took place each year in August from 1751 to 1833. During the second half of the eighteenth century they were among the most important races in the county.

Originally, Altisidora is a character in Cervantes' classic *Don Quixote,* a young girl who dupes Don Quixote in believing that she is in love with him.

Armstrong's Patent Co. Ltd

Armstrong's Patent Co. of Beverley, maker of shock absorbers, was founded in 1926 by inventor F. G. Gordon Armstrong in Eastgate. He started out with a garage in North Bar in 1907. In 1930 they became a private company, Armstrong's Patents Co., and in 1935 a public company, Armstrong Shock Absorbers Ltd. Armstrong were producing 4,000 shock absorbers a day by 1939, employing 450 workers. Gordon Armstrong was able to purchase and donate two Spitfires and a Hurricane for the RAF during the war.

By 1961 they were known as manufacturers of Armstrong shock absorbers, Helicoil screw inserts for the repair of spark plug threads, Strongarm door closers and hydraulic remote controls. The same year Armstrong Shock Absorbers changed its name to Armstrong Equipment, with Armstrong's Patents Co. a subsidiary company. In 1986 Armstrong's was making replacement exhausts for cars; the company won an appeal to the Law Lords against British Leyland to be allowed to make such exhausts without payment of royalty to BL. The Eastgate works was closed in 1981, with the loss of 300 jobs.

Armstrong's had a factory in York in Manor Lane, off Shipton Road. William's son – also William – took over in 1945, establishing a research and development

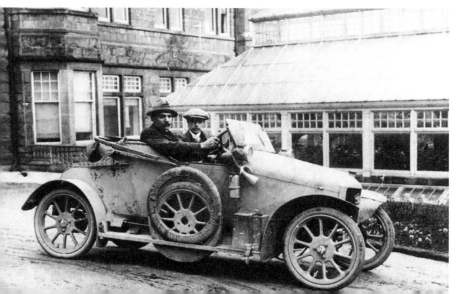

Gordon Armstrong and his car, 1914.

department in Fulford. He opened the York factory in 1949 to manufacture a new type of suspension unit for Ford cars and to establish the company's range of telescopic shock absorbers. The company later opened factories in Australia, Canada, the United States and South Africa. The York factory was expanded in 1965.

In 1989, after losing a £3.3 million contract with Nissan, the company was sold to the American firm Tenneco and the York factory became Monroe's. Further redundancies followed, and the factory closed in 2000 with the loss of the remaining 392 jobs.

Arctic Corsair

The *Arctic Corsair*, the deep-sea trawler, was built in 1960 at Beverley Shipyard by Cook, Welton & Gemmell for the Boyd Line, the Hull trawling company, and was the last of the Hull side fishing vessels, or 'side winders'. In 1973, the *Arctic Corsair* broke the world record for landing of cod and haddock from the White Sea.

A veteran of the Cod Wars, the *Arctic Corsair* rammed the Icelandic offshore patrol vessel ICGV *Odin* in the stern after *Odin* had made three attempts to cut the *Corsair's* trawl warps. With his ship holed below the waterline and patched up temporarily by the Royal Navy, the captain headed for Hull for permanent repairs. After a seven-year lay-up she returned to fishing in 1986, before being finally laid up for good in 1987. The vessel opened to the public as a floating museum in 1999 and has since attracted in excess of 20,000 visitors.

The *Arctic Corsair* is currently berthed on the River Hull between Drypool Bridge and Myton Bridge, at the back of the Streetlife Museum. However, in March 2019 she will be towed to Albert Dock for a full restoration and then towed back to the river to a new purpose-built berth in a dry dock at the former North-East Shipyard, off Dock Office Row.

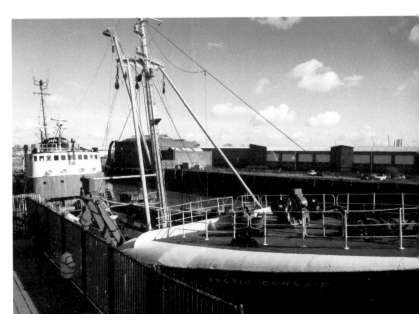

The *Arctic Corsair*, 2018.

B

Baptist Chapel, Lord Robert's Walk

The Beverley Baptist Church was established on 15 October 1833, and comprised thirty or so members who previously congregated in a room in Toll Gavel.

Beverley – The Name

Beverley is an Anglo-Saxon name and means 'beaver's clearing'. It was originally known as Inderawuda (meaning 'in the wood of the men of Deira') and was founded in AD 700 by St John (of Beverley) during the time of the Anglian kingdom of Northumbria. From the Vikings it passed to the Cerdic dynasty, when it gained religious prominence and became a place of pilgrimage throughout the Middle Ages on account of its founder. Beverley became a leading wool-trading town and was at one time the tenth-largest town in England, as well as one of the most prosperous.

Beverley is replete with street names that mirror its history. There's a Bull Ring and a Hengate, hinting at the livestock bought and sold here. Walkergate is nothing to do

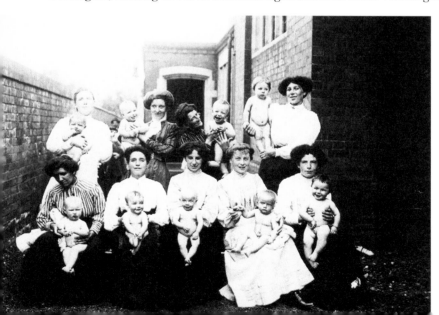

The Baptist Chapel babies and mothers, 1908.

with hikers, but tells us about the cloth fulling that went on. Wednesday Market and Saturday Market are self-explanatory, while Toll Gavel is the place where tolls were collected (OE toll + gafol = tribute, rent).

Flemingate is where the people from Flanders tended to live, while Loundress or Londoners Lane (and Londiners Street in 1660) was the place for London folk. As in York, gates are everywhere: Keldgate, the site of a spring, from 'ON kelda'; Ladygate, where the Church of Our Lady is; and Lairgate, leading to a barn, from 'ON hlatha'. You may not have wanted to go down Hellgarth Lane (a haunted field or denizen of criminals), or indeed Lurk Lane – a somewhat insalubrious part of town, frequented by unsavoury characters. Lurk Lane was mentioned, as Lort Gate, before 1280 and was called Lort Lane from 1342, presumably with reference to its dirty condition.

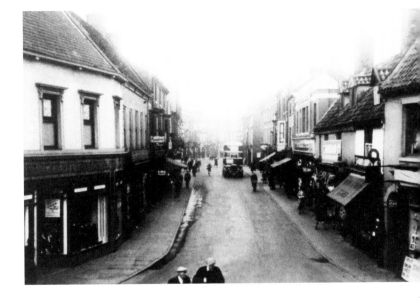

Toll Gavel looking towards Saturday Market in the 1930s.

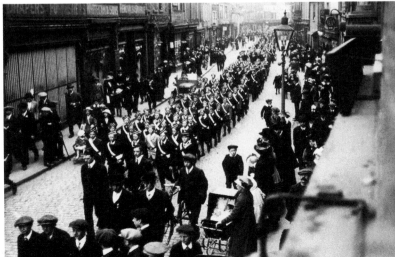

Boys' Brigade marching through Toll Gavel, early 1900s.

Walkergate,
1900.

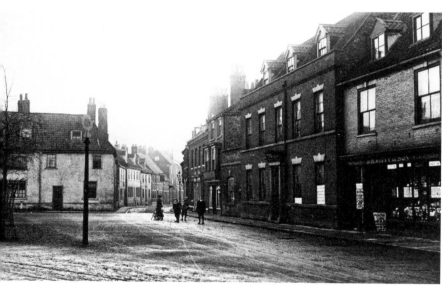

The Wednesday
Market, 1904.

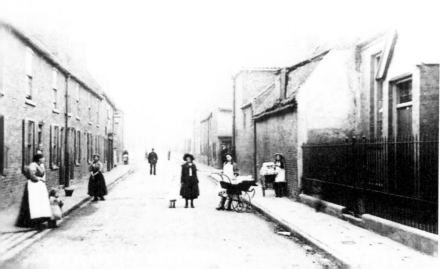

Keldgate,
c. 1900.

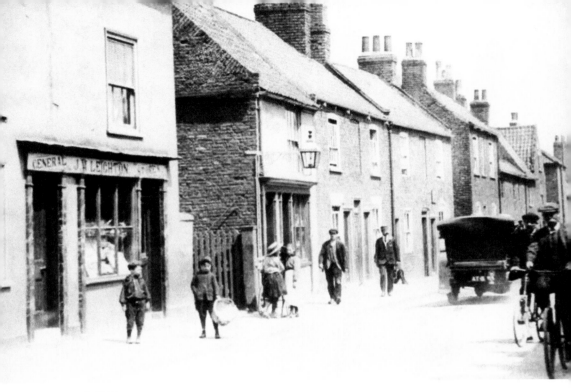

Papes Yard, Keldgate, *c.* 1900.

Beverley – Origins

The history of Beverley begins soon after the introduction of Christianity into Northumberland by Paulinus in 625. In 692, John, Bishop of Hexham, found a small parish church in the Deiran wood dedicated to St John the Evangelist. He rebuilt and converted the church into a monastery, with seven priests and seven clerks, and attached a nunnery called the Oratory of St Martin. He endowed these with lands at Middleton, Welwick, Bilton and Patrington, and with the adjoining manor of Ridings.

Beverley Arms Hotel

The Beverley Arms Hotel on North Bar Within, previously known as the Blue Bell Inn, was refurbished in the 1700s into the Georgian building you see today, and renamed from 1794 to the Beverley Arms. Originally, from the 1840s to the 1890s, it was a posting house on the turnpike road between Beverley and Hull. Dick Turpin allegedly stayed here before his appearance before the town magistrates in 1738. The 1851 census reveal Samuel Fiddes, aged sixty, his wife, sister-in-law, one male house servant, three female house servants, one post boy and one male waiter living in the hotel at the time. When the Morley family bought the property in the 1850s they were not just

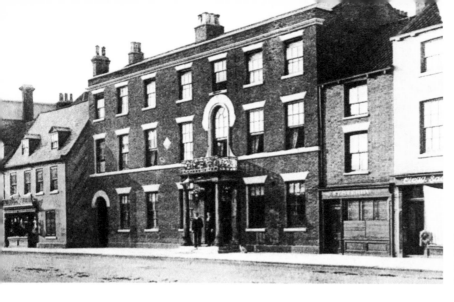

Photo taken in the 1860s for the hotel visiting card.

buying a hotel, but a billiard room, coach houses, a brewhouse, barns, outbuildings and a garden that extended the whole length of Wood Lane. A large paddock at the end of the garden was used for fêtes, travelling circuses and other shows.

Beverley (North) Bar

Beverley Bar or Beverley North Bar is a twelfth- to thirteenth-century gate between North Bar Without and North Bar Within, close to St Mary's. It is the only surviving brick-built town gate in the UK, and was part of the defences that surrounded the prosperous town. North Bar is the only survivor of the bars built then. It was rebuilt in 1409 (at a cost of cost £97 11d) and was renovated in the seventeenth century. In 1409, its main role was as a collection point for taxes; militarily, it was ineffective during the Pilgrimage of Grace and the Civil War.

The Bar is considered by archaeologists Oliver Creighton and Robert Higham to be the 'best surviving example in England of a brick-built town gate'.

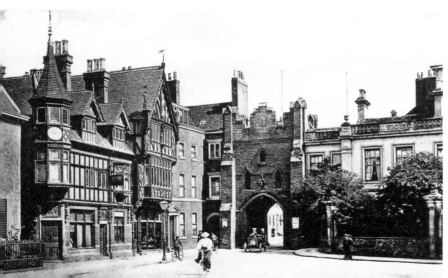

North Bar.

The bars served as toll gates with passage through them subject to a local tax. Here is an extract from 1420 when Henry V visited the town:

£17- 4s. 8d. received for pavage at the North bar this year by John Fletcher and John Grimsby collectors as appears by their accounts.

£2. Is. 9d. received by John Smyth the collector in Norwood for pavage this year as appears by his account examined and proved.

13s. 4d. received by William Read collector at Newbegin bar this year as appears &c.

18s. 4|d. received by Richard Batty collector at Keldgate bar for pavage as appears &c.

£2. 2s. 9d. received by John Fayr collector at the river for pavage this year as appears &c.

We know that North Bar was used as a viewing gallery for the town governors in the fifteenth and sixteenth centuries during the plays staged at the Corpus Christi festivals. In 1643, during the Civil War, the mayor, the Rt Hon. Manbie, ordered that North Bar, as well as Newbigin and Keldgate Bars, be locked by constables of those wards between nine at night and six in the morning.

Below left: Men (and a policeman) hanging round a bar.

Below right: PC Jones – still closing the gates in 1900.

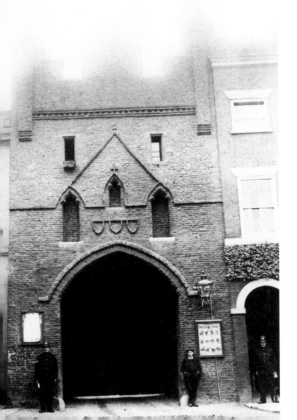

After the Civil War the defences of Beverley fell into disrepair. Newbigin, or Newbiggen, Gate was demolished in the eighteenth century and Keldgate in the nineteenth, while the town's ditch was filled in to allow urban expansion. North Bar itself only narrowly survived demolition in the early twentieth century when the council were considering options for improving access for double-decker buses.

Thankfully, it survived, no thanks to the council, when East Yorkshire Motor Services was commissioned to modify the roofs on the buses to fit under the arch – a rare case of common sense triumphing over 'civic vandalism' by authorities.

From the seventeenth century the area was important for agricultural fairs. In 1673 the bi-annual horse fair took place on the street within the Bar, while the bi-annual sheep fair was held in the street without the Bar. In 1686 the annual cattle fair was moved to the street within the Bar, and the sheep and horse fairs were moved to the street outside the Bar. The cattle fair was moved elsewhere in the town in 1865 and by 1959 all three fairs had moved well away.

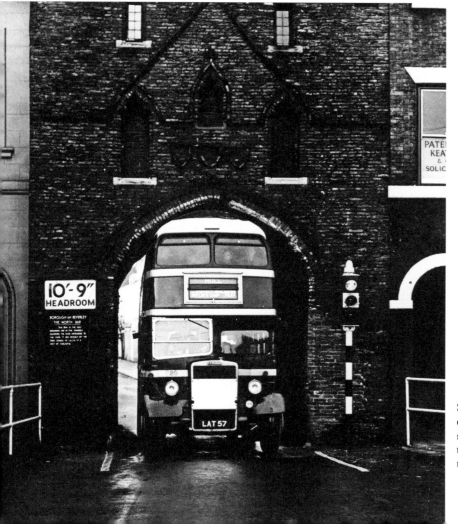

Specially designed buses shoehorning through the bar.

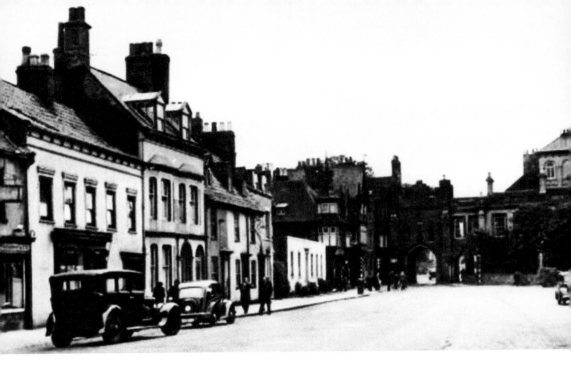

Above: North Bar
Without, 1922.

Right: North Bar
Within.

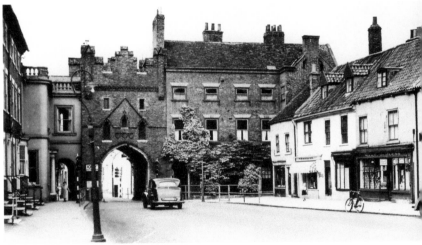

North Bar Without,
c. 1920.

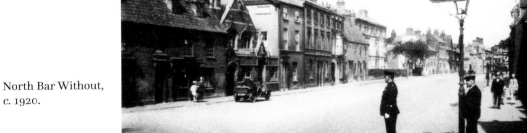

Beverley Beck and *MV Syntan*

Beverley Beck is a short canal that runs from Grovehill Lock on the River Hull at Beverley west for the best part of a mile into Beverley. Until 1802, the beck was tidal. In 1898, a steam engine was installed to top up the water levels in the Beck by pumping water from the River Hull. A multimillion-pound restoration was completed in 2007, with the refurbishment of the lock gates and pumping engine.

The Beck is home to the barge *MV Syntan*, owned by the Beverley Barge Preservation Society. The barge was built for Richard Hodgson, who owned the tannery in Beverley. It was moored on the Beck from 1949 until the 1970s and became part of a fleet of sixteen barges based on Beverley Beck. The fleet was used to carry coal and hides into the tannery and shipped vegetable raw materials used for tanning materials from India, South Africa and Paraguay. The barges also carried general cargoes such as grain, flour, paper and nuts to South and West Yorkshire. *Syntan* could carry a cargo up to 110 tons.

In the 1970s the Hodgson fleet was sold and *Syntan* was bought by Victor Waddington of Swinton to transport steel for a short time, after which she was laid up for almost twenty years at Doncaster Power Station where she was vandalised and cannibalised for parts. The barge, or what was left of her, was bought by the Beverley Barge Preservation Society in 2001 and restored over three years.

Beverley Beck, May 2007. (Courtesy of Keith D. under Creative Commons)

Buggs the cobblers in Beckside in the 1930s.

Beckside infants, *c.* 1900.

Records for the Beck reach back to in 1296, when the Archbishop of York had fish weirs removed from the River Hull so that boats could reach Beverley. Grovehill, formerly Grevale near the junction with the River Hull, was used as a mooring place for barges. By 1344 the Beck was navigable as far as Beverley. Tolls were introduced from 1704, while the wharf at Grovehill was later converted into a lock.

Beverley Britannia FC

In 1894 Beverley's local football team were Beverley Britannia FC. The team are pictured with the Robert's Hull and District Cup, which they won during the 1893/94 season.

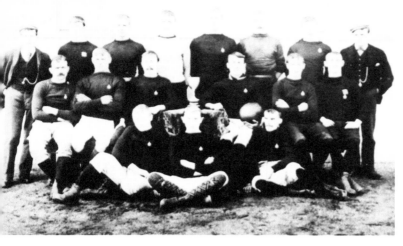

Beverley Britannia FC, 1884.

Beverley Grammar School

Beverley Grammar School is a boys' comprehensive state secondary academy school, which may have its origins in a school founded here around AD 700. Accordingly, the school claims to be the country's oldest state school and the eighth oldest school overall. The present school is a specialist engineering college and shares a mixed sixth form with Beverley High School.

The school is thought to be contemporary with Beverley Minster, with which it has been associated for centuries. Ketell's *Miracles of St John*, dating from around 1100, refers to a schoolmaster at Beverley. In 1306, the records of the chapter of the minster record the appointment of a new master of the grammar school (*scolas gramaticales*). Masters of singing and grammar were employed more or less continuously during the Middle Ages. The school disappeared after the Dissolution of the Monasteries. In 1552, the burgesses of Beverley petitioned the Crown for land worth £60 for the maintenance of the minster and also for the establishment of a new grammar school – the town at the time had a population of around 5,000 but no school. A schoolmaster is mentioned in the town's accounts for 1562, and in 1575 the town paid his whole salary.

A class in the 1930s – wake up boy on the second row!

In 1816/1817, the school moved away from the churchyard to a site next to the schoolmaster's house in Keldgate. Financial difficulties forced the school to close in 1878, but a new school was founded in 1890 in Albert Terrace, which also operated as a grammar school. It decamped to Queensgate in 1902.

The school motto – '*adolescentiam alunt, senectutem oblectant*' – is from Cicero's *Pro Archia Poeta*, a defence of the poet Aulus Licinius Archias against a charge of not being a Roman citizen under the 65 BC the Lex Papia de Peregrinis. The full quote is: '*Haec studia adolescentiam alunt, senectutem oblectant, secundas res ornant, adversis perfugium ac solacium praebent, delectant domi, non impediunt foris, pernoctant nobiscum, peregrinantur, rusticantur*' ('These studies sustain youth and entertain old age, they enhance prosperity, and offer a refuge and solace in adversity,

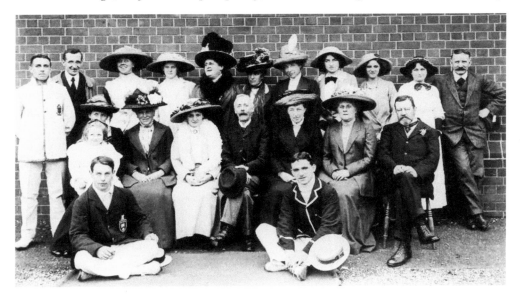

Above: Beverley Grammar School staff, 1910.

Right: Norwood sports ground, 1909.

they delight us when we are at home without hindering us in the wider world, and are with us at night, when we travel and when we visit the countryside').

Beverley High School is a girls' comprehensive school that was founded in 1908. It is located in Norwood.

Beverley Minster

When is a cathedral not a cathedral? When it is a minster. There is, however, very little distinction between the two. Minsters were originally, from the seventh century, any communal settlement of clergy where the act of prayer was routinely practised. They were later established as missionary teaching, collegiate, churches, or a church attached to a monastery from which monks would go out and preach to the local community. *Mynster* is the Old English equivalent of the Latin *monasterium* – a building not necessarily run by monks, but anywhere where a group of clergy shared a communal life.

A cathedral, on the other hand, was the seat of a bishop, his seat or throne – a *cathedra*. Cathedrals were the mother churches of a diocese. Examples of minsters other than Beverley are the minsters at York, Westminster and Southwell. Minsters declined in the eleventh century with the rise of the parish church and the name was then bestowed on 'any large or important church, especially a collegiate or cathedral church' – like Beverley. Beverley and York, then, are both a minster and a cathedral. The twentieth and twenty-first centuries have seen an upsurge in the number of parish churches honoured with the title 'minster'. Hull's Holy Trinity Parish Church being a case in point when, on 13 May 2017, it became Hull Minster.

Quite simply, Beverley Minster is a Church of England parish church. It is one of the biggest parish churches in the UK, larger than one-third of all English cathedrals

Pupils of Beverley Minster School for Girls outside Admiral Walker Hall, 1902.

and is regarded as a Gothic masterpiece. It is a collegiate church and, as a such, had no bishop's seat and so largely escaped the depredations of the Dissolution of the Monasteries; the chapter house was the only significant part of the building to be lost.

We have St John of Beverley, Bishop of York (706–714), to thank for the minster, who founded a monastery in the town in around 700. His remains lie in a vault beneath the current nave. In 1979–82, archaeology revealed that a major church stood on or near the present minster site from around 700 to 850.

Alternatively, another tradition holds that King Athelstan refounded the monastery as a collegiate church of secular canons with the gradual establishment of a major minster. By the early eleventh century Bishop John's tomb had become a magnet for pilgrims; he was canonised in 1037, which encouraged the growth of a town around the minster. The archbishops of York, the lords of Beverley, secured grants for four annual fairs, which boosted the town's commercial role. From the twelfth century Beverley was, of course, a major exporter of wool to the Low Countries.

A charter in the twelfth century tells us that substantial rebuilding work followed the canonisation of St John of Beverley in 1037. Archbishop Kynesige (1051–60) added a high stone tower. His successor Ealdred (1060–69) expanded the church with a new presbytery and a painted and gilded ceiling from the presbytery to the tower. Nothing remains of this Saxon church and no records of building work under the Normans survive; although there is evidence that the masonry was used as quarry for buildings throughout the town.

St Thomas Becket of Canterbury (1119–70) was provost of Beverley in 1154.

The fire of 1188 devastated the minster and the town. During the subsequent rebuild the central tower was unwisely heightened, only to collapse around twenty-five years later – around 1213. Much of the church was destroyed, necessitating further rebuilding. Reconstruction began at the east end in around 1230. Henry III granted forty oaks from Sherwood Forest in 1252, and by *c.* 1260 the retrochoir, choir, chapter house, transepts and crossing were complete. The Gothic masterpiece was born.

Beverley Minster from the north-west during a memorial ceremony for Edward VII on 20 May 1910.

Work continued, now in the more flamboyant Decorated style. Progress was on hold around 1348 due to the ravages of the Black Death and resumed later in the century when the nave was completed and the west front with its two magnificent great towers was built *c.* 1400. These towers are a superb example of the Perpendicular style, and formed the inspiration for the present west towers of Westminster Abbey, designed by Nicholas Hawksmoor.

In 1548, the minster was demoted to the status of a parish church; the college of secular canons, established before 1066, was dissolved, thus reducing the minster's staff from at least seventy-five to four; and the shrine of St John was dismantled. The chapter house was demolished. By the early seventeenth century the parish church of St Martin, formerly attached to the three south-western bays of the nave, was demolished.

Both west towers house bells. In the south-west tower there is a non-swinging bourdon bell called Great John from 1901. It weighs over 7 tons and it is over 7 feet in diameter. Despite its name, it is nothing to do with St John of Beverley, but is dedicated instead to St John the Evangelist. Records show that the minster had two bells in 1050. Four bells were later installed in 1366, three of which have been recast and are still in use today. The chimes for each were composed by renowned organist John Camidge.

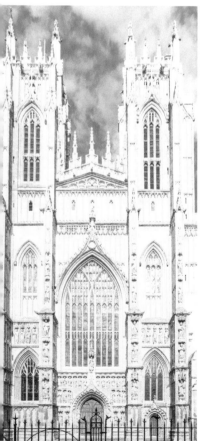

Above: Removing the old minster wall in 1905.

Left: The massive west front at Beverley Minster, August 2016. (Courtesy of Bellminsterboy under Creative Commons)

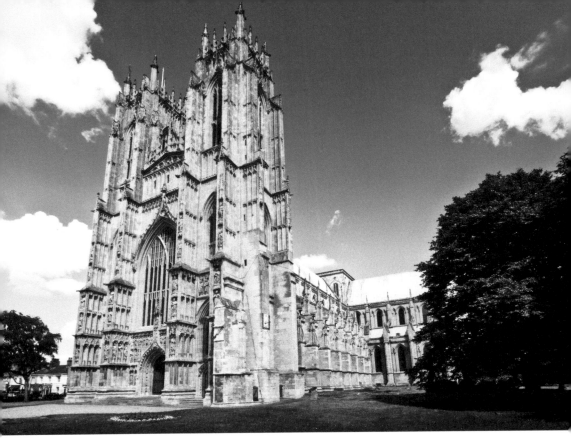

Beverley Minster, 2012. (Courtesy of Michael D. Beckwith)

The church contains one of the few remaining frith stools, or frid stools (meaning 'peace chairs') in England. Anyone needing to claim sanctuary from the law would sit in the chair. The chair dates from Saxon times. Over time, the frid stool has become the symbol of sanctuary. Beverley was a sanctuary town; if you had committed a capital crime you could claim sanctuary here and your sentence would be commuted – often to exile abroad. The whole town enjoyed this function and there are crosses on the boundaries to define the geographical limits of this provision.

In the central tower there is a massive treadwheel crane that was used to lift building materials to the roof space. It is medieval but has been largely reconstructed.

The organ is mounted above a richly carved wooden screen dating from 1877 to 1880, designed by Sir George Gilbert Scott and carved by James Elwell of Beverley. There is a staircase in the north aisle that was used in collegiate times to gain access to the chapter house, which has been long since demolished.

Black Mill

The exposed and windy Westwood was always a good place for anything wind-driven: kite flying is still popular today, as were windmills in the past. There were at least five

windmills working on the Westwood, but only three remain – all in a ruinous state. The real name of the Black Mill, a wind-powered corn mill, was Far Mill or Baitson's Mill, after Gilbert Baitson, the man who rebuilt it in 1803. A windmill has stood on this site since the 1650s. Of the other mills, one is next to the Beverley Golf club; this is the old Union Mill or Anti Mill. The third is Westwood Mill.

A Corporation mill is mentioned in 1577–78, presumably a windmill – a windmill was certainly built on Westwood a few years before 1625. The Corporation had a windmill on Westwood from 1646 to 1647, later known as First, Low, or Hither Mill. Ironically, it was blown down just before 1715 and was rebuilt in 1742. By 1856 it was dilapidated and the machinery and remains of the building were sold off. A second windmill, variously known as High, Far, Black, or Baitson's Mill, was later built by the Corporation close to Low Mill.

Known also as 'New Mill', Black Mill was mentioned from 1654 to 1655. The sails were blown down in 1868 and the mill was dismantled, but the tower was repaired and remained until 1988. In 1761 the Corporation let part of Butt Close, on the eastern edge of Westwood, with licence for the lessee to build a windmill. Butt Close or Fishwick's Mill was a post mill, and was demolished in 1861. Another mill was built in a close at the southern boundary of Westwood in 1802. It worked until the 1890s and the lower part of the tower was still standing in 1988. The Union Mill Society was formed in 1799 to run a co-operative mill, and in 1800 built the Anti-mill, as it was sometimes called, near the south-western corner of Westwood. The lower part of the tower has survived, becoming part of the golf course club house in 1988.

Black Mill.

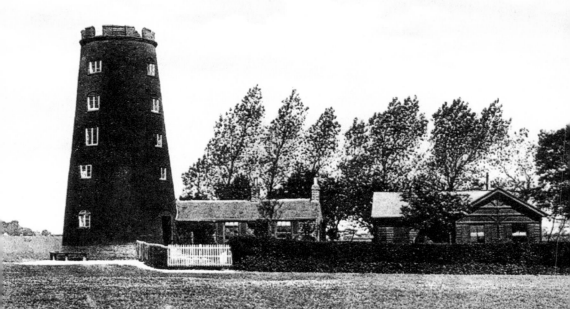

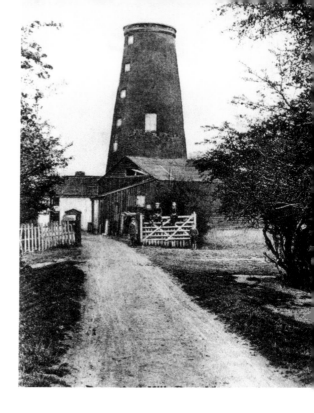

The 'Anti-mill', 1897.

Bolex Lane

This curiously named lane was known to us from the early fourteenth century. This, or Bullax Lane, was the original name for Bakhouse Lane as mentioned in 1326 and 1457. It ran from Ladygate to Walkergate and may have been named as such from the Bullock family. It was recorded as Bakhouse Lane from 1345. Beaver Road was mentioned as Boggle, Bogle, or Bog Hill Lane from 1843. By 1909 it was called Beaver Road. Butter Ding Flags was formerly known as Bishop Dings and was mentioned in 1282. By 1344–45 it was called the Dings, and by 1799 Butter Dings. In 1986 it was known as Butter Ding Flags. Cock Pit Hill was mentioned as part of Wednesday Market from 1648 and was also known as Old Waste. Dead Lane appropriately ran along the east side of St Mary's Churchyard, and was mentioned from 1329. It was stopped up by 1853. Dog and Duck Lane was formerly called Byrdal Lane, recorded in 1409, and was later known as Briddal Midding Lane (1433–34) after a local midden. By 1799 it was known as Dog and Duck Lane after a public house. Pudding Lane was mentioned – as Podyng Lane – in 1416–17 and may have been in the neighbourhood of Ladygate and Saturday Market. It was called Pudding Lane in 1556–57 and 1611. Raskel Lane was mentioned in 1446 and 1449–50 and lay on the north side of Flemingate. Sloe Lane was perhaps 'the lane towards the Friars Minor', mentioned in 1407. Slutt Lane, or Slutwell Lane, later became Albert Terrace. Sow Hill was mentioned from 1585. Tiger Lane was perhaps the 'lane called Cuckstool pit', mentioned in 1585, and was called Cuckstool Lane in 1828.

Charles Brown's Day at the Races, 1910

An enjoyable day at Beverley races was on the cards for Walter Henry Nozedar and his nephews Walter Edward and James William, from Raywell Street in Hull. What was not on the cards were three spruced-up prostitutes from Hull behaving indecorously, to say the least. They hurled obscenities at the three Nozedars as they passed by, to which Edward responded by confronting one of the women who threatened him with her hair pin. A crowd had soon formed, from which a heavily built man emerged demanding to know what the trouble was. This was Charles Brown, who thumped Edward to the ground and did likewise to Walter when he came to help. One of the prostitutes kicked Walter as he lay on the ground. James, too, was felled, before Brown threatened a charity collector from Hull Children's Hospital and stormed off to the beer tent.

When police arrived they examined Edward Nozedar, believing that he may well be dead. Brown had left with the three women in a wagonette. The police gave chase and Brown threatened the driver with a hammer, but was finally arrested and charged with assault. The women were charged with riotous behaviour and all three spent the night in the cells. A doctor from Newbegin, Beverley, later pronounced Edward dead and Brown was charged with feloniously killing and slaying Walter Edward Nozedar, a charge he refuted, blaming the death on the kicking administered by the women.

Brown, a bookie's helper from Leeds, was tried at York Assizes for manslaughter. Edward had died from a heart attack due to violent blows. Brown was found guilty. His inglorious record was read out in court: twenty-eight convictions in Leeds courts in his twenty-eight years. Five years' penal servitude is what he got in addition to the balance of a sentence he was already serving as a ticket of leave man. Two of the women went to jail for riotous behaviour. There were no winners that day at the races.

Civil War

At the start of the war Parliamentarian Hull refused Charles I entry. The Royalist Beverley took the king in instead and he spent three weeks as a guest in a house at North Bar in Beverley, where he was openly greeted with the peeling of St Mary's bells.

However, Beverley was taken by the Parliamentarians of Hull, and the king had to flee. A Royalist army led by William Cavendish defeated Thomas Fairfax to reclaim the town for the Royalists, from where they launched another siege of Hull. After the Parliamentarians won the war they set about destroying anything they considered to be idolatrous. Beverley Minster escaped any iconoclasm, partly due to the prominence of the Percy family and the fact that the church housed memorials to their ancestors. The restoration of the monarchy in 1660 with Charles II coming to power was well received in Beverley. His royal coat of arms was hung in the minster, where it remains to this day.

Cochranes

Andrew Cochrane founded a shipyard in 1884 at Beverley, but then moved his firm to Selby in 1898, where they built trawlers and coasters for the Hull and Grimsby fishing fleets. According to *Grace's Guide to British Industrial History*:

In WWI the yard made 90 steam trawlers for private owners, 70 steam trawlers for the Admiralty which were deployed as minesweeper, gunboats and barges. The yard was able to achieve such a massive output by building the trawlers ten at a time in five pairs. In addition the yard was laid out in such a way so that ships could be launched two at a time and construction could take place rotationally with members of staff working on one task at a time for two weeks before the next task was undertaken.

Altogether Cochrane's built 245 vessels between 1884 and 1901.

Cook, Welton & Gemmell

By the mid-nineteenth century the building and repair of wooden ships was long established at Grovehill, as well as besides Beverley Beck where a second dry dock was made near the lock in 1858. The first company to make iron vessels were Henry and Joseph Scarr, who started off with an engineering works near the head of the Beck. In 1882 they launched two iron boats, the first next to their works and a larger one a little further down the Beck. In 1884 a dredger 70 feet long and with a beam of 23 feet had to be taken to the lock to be launched. In the 1890s Scarrs moved to a more spacious yard by the river, in Weel.

In 1882 a larger firm, the Vulcan Iron Co. of Hull, built a shipyard on land owned by the Corporation at Grovehill and began producing bigger ships, including two ocean-going vessels of 1,500 tons. The decision to open the Vulcan shipyard may well have been influenced by the closure of the Beverley Iron & Waggon Company's works, which offered a supply of experienced iron workers. When Cochrane's took over the

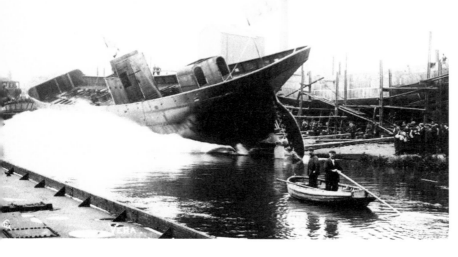

Launching *The Vera* at the shipyard in 1907.

yard in 1884 it was hoped that shopkeepers in the town would regain the income from the 'upwards of £500' in weekly wages, which the workers had lost when the ironworks was closed. Two years later, though, the company was wound up and the yard was let to Cochrane, Hamilton & Cooper. This, in turn, folded in 1900 and the yard was taken over by Cook, Welton & Gemmell of Hull in 1901.

If Beverley lost Cochrane's to Selby, the shipbuilding tradition in the town was more than compensated by Cook, Welton & Gemmell.

The firm was founded in 1883 on South Bridge Road, Hull, on the banks of the Humber by founding partners William James Cook, Charles Keen Welton and William Gemmell, three former employees of Earle's Shipbuilding and Engineering Co. of Hull. They had set up their own company in 1882, initially to undertake repairs and then build vessels themselves. The first ship to be made by the yard was a steam fishing smack.

The company moved to a new yard in Grovehill, Beverley, in 1901. They took over the Grovehill shipyard from Cochrane, Hamilton and Cooper, which had previously been owned by Cochrane & Sons. The first production of the new yard were trawlers and whalers. They dredged the River Hull, allowing larger ships to be built. In 1901–02 the business relocated 9 miles up the River Hull to a new yard at Grovehill, Beverley, purchased from Cochrane, Hamilton & Cooper who had moved to Selby. The yard had been founded by Andrew Cochrane in 1884 and was one of the few shipyards that launched broadside.

It was here where the Cook, Welton & Gemmell played a vital part in the First and Second World Wars, converting trawlers for military use and building mine sweepers, anti-submarine patrol boats and tugs.

One trawler constructed here was the *Viola*, a small trawler built for fishing in the North Sea that went on to become an unsung heroine of the First World War. Built in 1906 by the Hellyer Steam Fishing Company, the *Viola* was requisitioned by the Admiralty to become one of the first vessels to use depth charges against submarines.

In the interwar years it strengthened its reputation as a builder of high-quality trawlers. In 1954 the shipyard employed 650 workers and built fifteen vessels

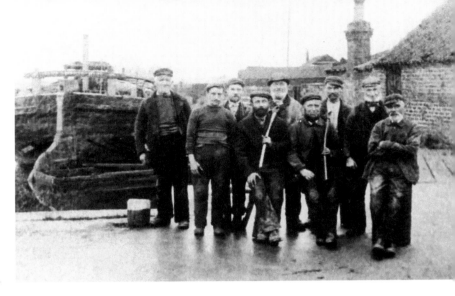

Shipbuilders at
the yard in 1901.

(including three minesweepers, four trawlers and a tug), but by 1960 the workforce
had declined and orders were drying up. Cook, Welton & Gemmell built their last ship
in 1962 and went into voluntary liquidation in 1963.

There then followed a series of ownership changes. The firm was taken over by
Charles D. Holmes & Co. in March 1963 and changed its name to Beverley Shipbuilding
and Engineering Co. Ltd. C. D. Holmes was subsequently taken over in 1973 by Drypool
Group, which in turn went into liquidation in 1975. The yard was then taken over by
Whitby Shipyard Ltd in July 1976, which changed its name to Phoenix Shipbuilders Ltd in
December 1976 and had a receiver appointed in May 1977, resulting in the closure of the
Beverley yard with nearly 180 redundancies. The site reverted to the ground landlords,
Beverley Borough Council and was later developed as the Acorn Industrial Estate.

The Corn Exchange and Picture Playhouse

This present building replaced an earlier Corn Exchange. The Old Corn Exchange
building stood at the end of Saturday Market (known as Corn Hill) from the
seventeenth century, and was converted from the old Butchers' Shambles building
in 1825. The later Corn Exchange is dated 1886 and is built on the site of the Old Corn
Exchange, the old corn market, fish and meat shambles and butter market. Corn was
last sold here in 1947. Swimming baths were also opened in 1886 and closed in 1973.
The baths were small and this led to some locals referring to them as the 'Beverley
puddle'. Initially they were slipper baths for local people who had no bathrooms in
their homes. During the Second World War the baths were closed and requisitioned
into a decontamination centre to deal with gas attacks.

In 1911 the Corn Exchange was converted to the Picture Playhouse by Ernest
Symonds, a local entrepreneur and film maker. The first regular motion pictures

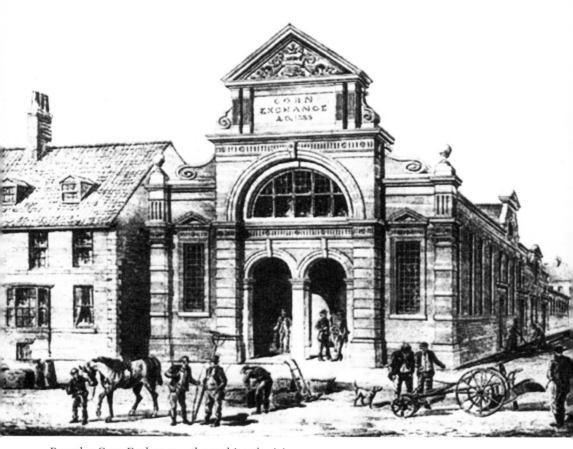

Beverley Corn Exchange – the architect's vision.

in Beverley were screened here. It is situated in the Market Place at the corner of Ladygate. Originally seating 425 on a flat floor, it later seated a lot fewer in raked seating. The Picture Playhouse was also a major venue for live music in East Yorkshire. It closed in September 1963 but was reopened in April 1982. It was the only surviving cinema in the town, the 1916 Marble Arch Cinema and the 1935 Regal Cinema having both been demolished.

In 2002, The Playhouse was suffering from competition in the form of Hull's multiplex cinemas and closed in 2003. It was converted into Browns Department Store.

On the junction of Norwood & Manor Road, the Regal Cinema opened on 2 November 1935, incorporated (unrecognisably) into the fabric of the eighteenth-century Assembly Rooms extension. Operated first by a local exhibitor, it was taken over by Associated British Cinemas (ABC) in 1937. ABC closed the Regal Cinema on 22 June 1968 and it became a bingo and snooker club. By 1993 the building was derelict.

It was designated a Grade II listed building. This was, unsurprisingly, for its eighteenth-century Assembly Room fragments rather than the cinema part of the building. The building was demolished in 1998 and housing/retail complex Regal Court was built on the site.

The Assembly Rooms before they became the Regal Cinema in 1935.

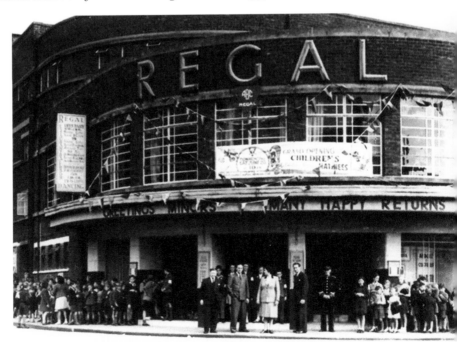

The Regal.

Norwood, 'The Gate', with motor cars, 1914.

Crosskill's Ironworks

The largest industry in Beverley in the mid-nineteenth century was Crosskill's ironworks. The firm had been set up by William Crosskill, a whitesmith, by 1825, when it began to make articles in cast iron such as railings and lamp standards for the Beverley Gas Company. In 1844, Crosskill provided lamp standards for the street lighting system installed in Hamburg, and from 1849 a branch in Liverpool sold kits of emigrants' tools. Crosskill had expanded into the manufacture of agricultural machinery in the 1830s, which increasingly became the firm's focus. The Crosskill catalogue displays a wide range of machines, the best known being the clod-crusher, of which 2,478 were sold by 1850. Ploughs, harrows, and threshing machines were also sold in quantities. In 1847, Crosskill's was in financial difficulty and was mortgaged to the East Riding Bank. During the Crimean War the firm produced over 3,000 army carts and wagons and some ordnance; however, in 1855, when trade in Hull was depressed as a result of the war, the bank foreclosed.

After the discovery of some financial irregularities, the firm was sold in 1864 to a company headed up by Sir Henry Edwards, the Conservative MP for the town. The firm then continued under the name of the Beverley Iron & Waggon Co., but was closed in 1879 with the loss of up to 300 jobs and debts of £24,000. The Mill Lane premises were sold off and much of the site was used for a recreation ground and the Cottage Hospital in the 1880s. In 1864, Crosskill's sons Alfred and Edmund had set up a rival firm, trading as William Crosskill & Sons on a site in Eastgate. They continued to make railway wagons and farm carts there until 1904, when they in their turn were taken over by the East Yorkshire Cart & Waggon Co., which had until 1880 been known as Sawney & Co. This had works in Trinity Lane, which William Sawney first occupied in 1862. As the East Yorkshire and Crosskills Cart & Waggon Co. it eventually went into liquidation in 1914. A later resurrection of the firm was short-lived.

D

Frederick Deeming: Beverley and Jack the Ripper?

Frederick Bailey Deeming (1853–92) was an English-born Australian gasfitter, but is far better known as a murderer. He was convicted and executed for the murder of a woman in Melbourne, Australia, and is remembered today as possibly being none other than Jack the Ripper. He murdered his first wife Marie and his four children at Rainhill, St Helens, in July 1891, and a second wife, Emily Mather, at Windsor, Melbourne, on Christmas Eve 1891. He married his first wife, Marie James, in Tranmere in 1881 and lived for a short while in Birkenhead before leaving for Melbourne. By 1886 Deeming and Marie had two Australia-born daughters, Bertha and Marie. In 1888, he announced that he and his family were returning to England 'with a considerable fortune'.

His association with East Yorkshire stems from the fact that it was to Hull that he returned and took lodgings in Beverley, where he courted Helen Lydia Matheson, the twenty-one-year-old daughter of his landlady. He married her, bigamously, in St Mary's as Albert Williams in September 1891. Some say he dumped his new bride in their honeymoon suite at the Royal Station Hotel in Hull then visited photographer William Barry, where he posed in his wedding suit and a stolen Masonic outfit. He's then said to have bought a new travel suit, for which paid cash. He bounced a cheque for £285 worth of jewellery and left for South Africa the next day on the steamer SS *Coleridge*.

Others maintain that after leaving Beverley and honeymooning in the south of England, he suddenly disappeared. In the meantime he gave the first Mrs Deeming several hundred pounds, telling her he was leaving for South America and would later send for her and the children. Before leaving he swindled a jeweller's in Hull and was arrested for this in Montevideo, extradited back to England on a charge of 'obtaining goods by false pretenses' and was sentenced to nine months prison. On release, Deeming stayed in a hotel in Rainhill and later moved into Dinham Villa, where he complained that the drains were broken and that a new kitchen floor was needed. Eighteen months later the decomposed bodies of Marie Deeming and the four children – Bertha (aged ten), Mary (seven), Sidney (five) and Leala (eighteen months) – were found buried beneath the kitchen floor. In each case their throats had been cut, with the exception of Bertha who had been strangled.

In November 1891, Deeming sailed with Helen Matheson to Australia. They rented a house in Andrew Street, Windsor, a suburb of Melbourne. On 24 December, or early on 25 December 1891, he murdered Mather and buried her under the hearthstone in one of the bedrooms, covering the body over with cement. Deeming left, but on 3 March 1892 a tenant complained of 'a disagreeable smell' in the second bedroom. The owner and estate agent lifted the hearthstone to investigate, only to be met by a suffocating smell whereupon 'they found themselves barely able to breathe'. The police found Mather's body and a post-mortem revealed that Matheson's skull had been fractured by several blows, but that she had died from a cut throat.

Deeming was tried at Melbourne Supreme Court on 25 April 1892. A plea of insanity failed and he was sentenced to death. He was refused leave to appeal and on 19 May 1892 Deeming hanged.

Defence School of Transport

The Defence School of Transport (DST) is in Leconfield on the site of the former RAF Leconfield, now known as Normandy Barracks. When RAF Leconfield was closed the site was handed over to the army for use as the Army School of Mechanical Transport in 1977. In 1996 the school was rebadged the Defence School of Transport when it became responsible for training the Royal Navy, the British Army and the RAF. It is Europe's largest driver training establishment.

The school, a state-of-the-art centre of excellence, provides 150 or so different courses on all things transport for nearly 20,000 trainees a year. Training is provided on various forms of transport equipment up to and including the 60-ton Kalmar RT240 rough terrain container handler. The Driver Training Wing provides training leading to licences for all large goods vehicles, and the Advanced Training Wing provides training for logistics officers, driving examiners and instructors. This is what the DST website tells us:

> 110 Training Squadron administer and manage the transition of all RLC vocational drivers from basic training into their chosen career trade. All RLC ITT trainees are assigned to 110 Trg Sqn for the duration of their driver training, and from there they will then be assigned to their unit in the Field Force. The function of 110 Trg Sqn is to ensure students are managed through the driver training pipeline and at the same time maintain their mandated basic soldier skills … The main effort for MDTS is the delivery of military driver training to ITT and STT soldiers on military wheeled platforms such as conversion to Landrover, MAN Support Vehicles (6T and 9T) and DROPS … MDTS Combat Troop (military multi capbadge instructors) are responsible for the delivery of GS MOD 2 for all capbadges and the delivery of Basic Close Combat Skills (BCCS) and Anti Ambush to RLC personnel.

Domesday Book (1086)

Hundred: Sneculfcros. Beverley was one of 26 places in the hundred of Sneculfcros.

Area: East Riding County: Yorkshire.

Total population: 18.7 households (= heads of household) (medium). Total population would therefore be up to five times this number.

Total tax assessed: 10.7 exemption units (very large).

Taxable units: Taxable value 32 exemption units. Taxed on 31.0.

Value: Value to lord in 1066 £44. Value to lord in 1086 £34.

Households: 38 villagers. 15 smallholders. 3 men-at-arms.

Ploughland: 18 ploughlands (ploughs possible). 5 lord's plough teams. 15 men's plough teams (8 oxen).

Other resources: Woodland 3 * 1.5 leagues. 3 mills, value 0.65. 1 fishery. Tax on woodland is usually paid in pigs.

Lords in 1066: Beverley (St John), canons of; York (St Peter), archbishop of.

Overlord in 1066: York (St Peter), archbishop of.

Lords in 1086: Beverley (St John), canons of; York (St Peter), archbishop of.

Tenant-in-chief in 1086: York (St Peter), archbishop of.

Dyer Lane

Dyer Lane was originally Bowbridge Lane. Construction work here in the 1980s uncovered some large pits now buried below the shops on the north side of Dyer Lane. The pits were used for dyeing cloth – hence the name. For many years the dyes could only be 'fixed' by the application of a mordant. The ammonia extracted from urine was one method of fixing the dye. Buckets would be left around the town for residents to fill, which were then collected for the dye works.

East Riding Lunatic Asylum

Located in Broadgate, Walkington, this was renamed Broadgate Mental Hospital in 1949. It had opened in 1871 with 100 patients transferred from the North Riding Asylum at York. It closed in 1981.

The first asylum in Europe was the Bethlem Royal Hospital in London, built as a priory in 1247. It became a hospital in 1330 and admitted its first patients in 1407. Before the Madhouse Act of 1774, treatment of the 'insane' was carried out by non-licensed practitioners, who ran their 'madhouses' for profit. The Mad House Act made licensing mandatory to house patients, with yearly inspections of the premises. In 1792, the groundbreaking and enlightened York Retreat was set up by William Tuke – the first establishment in the UK to treat their patients humanely and offer them a therapeutic setting. Mechanical restraints were discontinued, while work and leisure became the main treatment; however, this was untypical and exceptional. In 1808, the County Asylum Act was passed, which allowed counties to levy a rate in order to fund the building of county asylums. The aim was to transfer the 'insane' who were then living within workhouses to the new asylums. However, only twenty county asylums were ever built. It was only after the passing of the County Asylum/ Lunacy Act in 1845 that construction took off, as the Act required counties to provide an asylum for the mentally ill living within their boundaries.

Most women were admitted for short periods simply to recover from the stress and exhaustion of their domestic lives. Women were also admitted from problematic marriages or as a result of giving birth to illegitimate children – even if as a result of rape. Post-natal depression was also a common reason for admitting women.

Fred Elwell (1870–1958)

Fred Elwell was born and bred in Beverley and was trained in draughtsmanship by his father, James Elwell, a skilled wood carver. Fred trained at Lincoln School of Art and attended academies in Antwerp and Paris. He painted a portrait of George V in 1932. In 1938, Fred was elected full membership of the Royal Academy. He exhibited at the

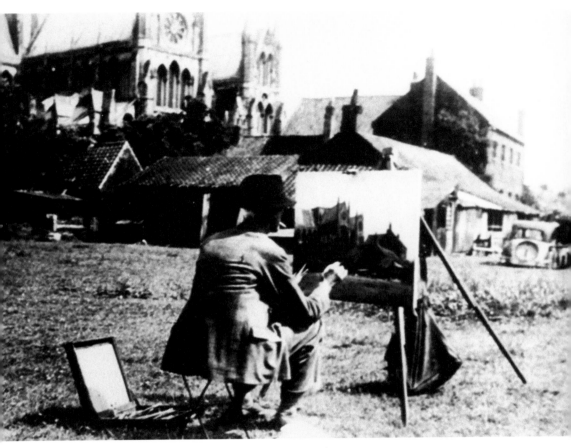

Fred Elwell painting the Admiral Duncan Inn and Beverley Minster, 1939.

Paris Salon and the Royal Academy and was made a freeman of Beverley, producing more than 500 paintings and working right up to his death in 1958. On his death, many of his paintings were gifted to Beverley Art Gallery.

The Admiral Duncan Inn, also known as the Hallgarth Inn as its address was Hallgarth, in Beverley Parks was named after Admiral Duncan, the naval hero who defeated the Dutch at Camperdown in 1797. In 1896 the Beverley Quarter Sessions revoked the licence giving as the reason that it was 'unnecessary'. The buildings, including the farmhouse, which remained in use, were demolished in 1958.

Celia Fiennes (1662–1741)

This intrepid lady traveller journeyed the length and breadth of the country, often with only one or two maids in attendance. Ms Fiennes's journey diary was later published in *Through England on a Side Saddle in the Time of William and Mary*. The enterprising and fearless traveller called in at Beverley around 1712. This is how she described the town:

> A very fine town for its size. Its preferable to any town I saw except for Nottingham. There are 3 or 4 large streets, well paved, bigger than any in York, the other lesser streets about the town being equal with them. The market cross is very large. There are 3 markets, one for beasts, another for corn and another for fish, all large. The town is served with water by wells, there are many of these wells in the streets. The buildings are new and pretty lofty. The Minster is a fine building

Pony and traps in the winter mist at Walkington, 1900.

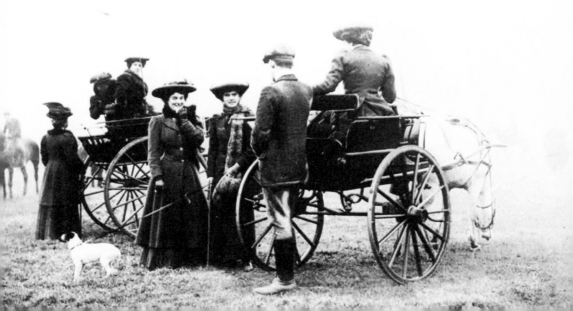

all stone, carved on the outside with figures and images. There is another church called St Mary's that is fine and good. There is a very good free school for boys, they say the best in England for learning and care.

Cardinal John Fisher (1469–1535)

John Fisher was born in Beverley in 1469, the eldest son of Robert Fisher, a merchant of Beverley, and his wife Agnes. Fisher was first educated in the school attached to the collegiate church, the minster. He then attended Beverley Grammar School. He became an English Catholic bishop, cardinal and theologian. Fisher also served as chancellor of the University of Cambridge.

Fisher was executed by Henry VIII during the Reformation for refusing to accept the king as supreme head of the Church of England and for upholding the Catholic Church's doctrine of papal supremacy. He was named a cardinal by Pope Paul III shortly before his death. He is honoured as a martyr and saint by the Catholic Church. He was a devoted, industrious and very serious man. Fisher was known to place a human skull on the altar during Mass and on the table during meals, presumably to instil the fear of god in his congregations. Erasmus said of John Fisher: 'He is the one man at this time who is incomparable for uprightness of life, for learning and for greatness of soul.'

You could never call him patriotic, however. Fisher engaged in clandestine activities to overthrow Henry VIII. In 1531 he was communicating with foreign diplomats and in 1533 he encouraged Holy Roman Emperor Charles V to invade England and depose Henry, coinciding with a domestic revolution. His defence of Catherine of Aragon had alienated Henry irrevocably. His elevation to cardinal was the last straw, and Fisher was found guilty of treason and condemned to be hanged, drawn and quartered at

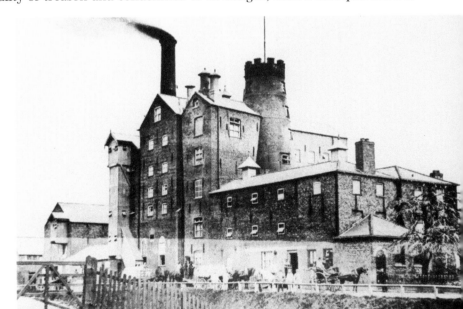

Crathorne's flour mill, 1890.

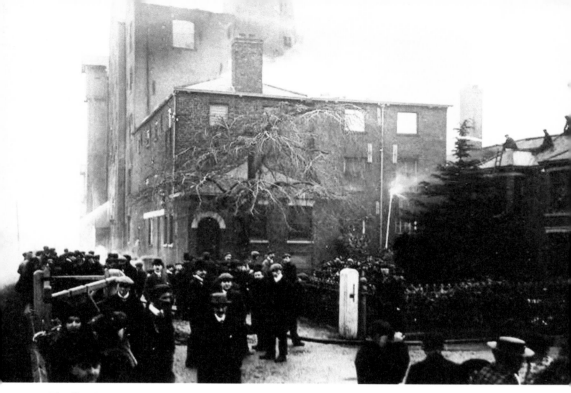

The fire in 1907.

Tyburn, later commuted to beheading. For Henry there were uncomfortable parallels with the execution of St John the Baptist's execution. His body was abused on Henry's orders, being stripped and left on the scaffold until the evening, when it was taken away on pikes and thrown naked into a rough grave in All Hallows' Churchyard, Barking. Fisher's head was stuck up on a pole on London Bridge, but its lifelike appearance caused so much alarm that it was thrown unceremoniously into the Thames after a fortnight.

Crathorne's Flour Mill

Built in 1830 and water-powered, it was one of nine such mills in Beverley in 1834, reflecting the strong position of grain milling in the town. There were five mills on or near Westwood, two at Grovehill, and one, along with a water mill, in Hull Road. Josiah Crathorne had started milling at Grovehill around 1830 and by the 1850s he was using steam as well as wind power. The mill was later enlarged and, with its favourable situation beside the River Hull, Crathorne's was able to make the change to roller grinding of imported grain. However, the flour-production bubble burst, and by 1880 only Crathorne's remained. The factory was destroyed by fire in 1907 and was never rebuilt – the owner had no insurance and went bankrupt as a result of the fire.

Highgate, with Monk's Walk on the left.

Walkington Board School pupils outside the Dog & Duck.

The French Horn

A long-lost, but delightfully named, pub that stood in Highgate. It may have been located in the same place as The Greyhound at the northern corner of Ladygate and Dog & Duck Lane, opposite The Dog & Duck Inn. 'Dog and ducks' pubs refer to the old and nasty sport of setting a duck loose (with wings pinioned) on a pond and letting dogs race in after them and tear them to shreds; diving was their only hope of survival.

The Old Friary

These venerable buildings are either part of an old Dominican friary or were built on the site of the friary using stone from the site. A Dominican friary was first established in Beverley in around 1240, or even 1210. The Dominicans were gifted a parcel of land close to Beverley Minster by the Archbishop of York. Here, the Blackfriars (as the

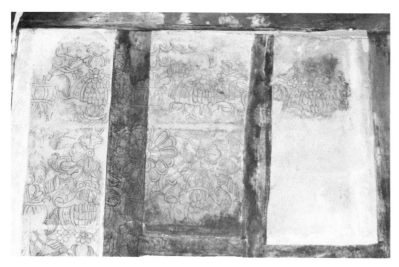

Wall painting inside the upstairs hall of Beverley Friary. The painting is believed to be late fifteenth or early sixteenth century and was rediscovered during restoration work in the 1970s. (Courtesy of Nthep under Creative Commons)

Dominican order were often known) built their first friary – probably with timber. In time, the community flourished and the friary was extended in the early fourteenth century. It is the foundations of this building on which the present-day buildings stand. In 1539 the Dissolution of the Monasteries saw the remaining friars expelled and the property wrecked; it is thought that the guesthouse survived demolition because it was not being used directly for religious purposes.

In the nineteenth century much of the site was built over for the construction of the railway between Hull and Bridlington. The guesthouse became three separate dwelling houses – Nos 7, 9 and 11 Friary Lane – and continued as such until the 1960s when ownership passed to Armstrong Patents Co. Ltd, who owned the adjacent factory. In 1962, with a complete disregard for local heritage, Armstrong's applied for permission to demolish the buildings. Permission was refused and the houses made the subject of a preservation order with preservation work beginning in 1974. Since 1984 these buildings have been used as a youth hostel.

Frithman of Beverley

When William the Conqueror sent Toustain, one of his most ruthless henchmen, to loot Beverley Minster and drag out the people who had quite legitimately taken refuge in there he could never had anticipated that, at the very moment Toustain approached the altar, St John would fell him with a blinding light and, in a scene reminiscent of *The Exorcist*, all his limbs would swell up and his head revolve in a full circle.

This is what is said to always happen when you violate the ancient right of sanctuary granted to Beverley by King Æthelstan, the first Saxon king of all England in 938, who, unluckily for Toustain, attributed his victory over the Scots to the intervention of St John. In gratitude, Æthelstan had a firth stool placed in Beverley, the sanctuary

area of which extended for a mile and half in any direction from the stool. If someone was accused of a capital crime, they could temporarily save themselves by claiming sanctuary there. If their accusers attempted to seize them within this holy bubble, they would face a crippling fine. Dragging a man away from the altar or off the frith stool itself was punishable by death.

The word 'frith' comes from the Old Englifh *fiðu*, meaning 'peace, protection and safety'. It has many different associations in Anglo-Saxon culture, but *friþgeard*, meaning 'sanctuary', was an enclosed sacred space where the gods were worshipped.

After the Conquest there were two kinds of sanctuary. The first, and best known, was the general sanctuary afforded within any church, which could be claimed by grabbing the door knocker or by touching the altar. But that did not always solve the immediate problem: the church was supposed to feed and protect you, but in reality you would often be hounded out when your accusers surrounded the building and blockaded it – siege tactics by any other name.

The second kind was the Beverley kind, but this was rare, and far between, granted to a handful of places only by charter. These included Battle Abbey, Beverley, Colchester, Durham, Hexham, Norwich, Ripon, Wells, Winchester Cathedral, Westminster Abbey and York Minster. You had to choose where you committed your crime very carefully to benefit from this sort.

Sanctuary crosses or stones in the town marked the boundary of the sanctuary area around these churches. The period of sanctuary granted varied between churches, but most were between thirty to forty days. There were exclusions, though, in the medieval small print: anyone accused of heresy, serfs, Jews or anyone who had been excommunicated. Of course, sanctuary rights were occasionally disregarded, as when John of Gaunt's men murdered Frank de Hawle by stabbing him twelve times in Westminster Abbey when he claimed sanctuary there.

When your sanctuary time was up you had to try to escape or, if in Beverley, you could opt to become a frithman of Beverley by swearing to serve the Church and surrendering all your worldly goods to the Crown. Also, you could never legally leave the town again.

A third option was to plead guilty and swear to 'abjure the realm' in order to escape the death penalty. If this was accepted, the guilty man was obliged to walk barefoot to a designated port along the king's highway, dressed in penitential rags and carrying a cross staff as a symbol that you'd been granted safe passage. At the port you had to stand knee-deep in the sea during daylight until you could find a ship willing to take you into exile abroad. Obviously, the victim or victim's relatives did everything they could to ensure you never reached the ship alive, and many ex sanctuary seekers ran off as soon as they were out of sight of the authorities. But this came at a price, which brought you full circle: you would then be declared 'a wolf's head', permitting anyone to kill you with impunity and claim a bounty.

The good news is that the 1,000-year-old frith stool is still inside Beverley Minster. The bad news is that the right to sanctuary there was abolished by Henry VIII in the 1530s.

Guildhall

The original building on this site was purchased by the Beverley town keepers in 1501 for use as a Guildhall, and it has been in continuous civic use since then. Today, although it doubles as a historic building and community museum, it is still used for ceremonial civic occasions. The highlight is the breathtaking Georgian courtroom featuring plaster stucco work by Giuseppe Cortese, the world-renowned Swiss-Italian stuccoist (1725–78). Original timbers, dating back to the early fifteenth century were recently uncovered in two of the rooms.

The year 1762 was a pivotal one. Local builder William Middleton created a magnificent courtroom decorated with the Cortese stucco ceiling. An imposing façade, modelled on the Greek temple of Apollo at Delos, was added in 1832 by Hull architect Charles Mountain the Younger. Much of the original seventeenth- and eighteenth-century furniture commissioned by the town Corporation can still be seen, including a unique mayoral 'bink' or 'bench' dating from 1604 in the Magistrates' Room.

From around 1703 until 1810, quarter sessions were held in the Beverley Guildhall. Justices of the Peace frequently sentenced criminals to transportation here in the eighteenth and early nineteenth centuries. Among those sentenced in the Guildhall to transportation to Australia include John Best of Beverley, a labourer, sentenced in January 1788 and transported on the Third Fleet in 1790–91; and John Raper of Beverley, at the Christmas Quarter Sessions in 1796.

H

Jane Hostler and Elizabeth Beal

Long Riston is a village midway between Hull and Beverley. It was the home of little Thomas Hostler, his mother and father William and Jane, and his aunt, Elizabeth Beal. The three adults had been savagely abusing Thomas over a long period of time; in fact, it was so bad that four neighbours felt it necessary to take out a recognisance against the abusers, so confident were they that their action would succeed and they would not lose their £30 (each) deposit. The assize records spoke of beatings with 'hands and feet and staves and sticks' on every part of Thomas's naked body, leading to 'large and grievous wounds, swellings and bruises'. In short, the toddler was beaten to within an inch of death, until, finally, his parents' sadistic actions killed him. The women were recorded as being guilty of murder, along with William Hostler. His entry, though, was mysteriously amended to 'not guilty'. No one knows why. The women were transported to Van Dieman's Land via the pillory and a dungeon in York Castle.

Hodgson's Tannery, Flemingate

By 1901, tanning probably employed more men than any other occupation in Beverley. In 1851 there were six tanning firms situated along the southern edge of the town, the largest being those of William Hodgson, George Cussons and George Catterson. Hodgson's, which had been set up in 1812, became the biggest, making average annual profits of over £2,000 between 1832 and 1850. In 1851, Hodgson's employed seventy men and in 1890 as many as 450. With its position near the head of the Beck it had easy access to a supply of imported hides, and, as we have seen, by the twentieth century it owned a fleet of fifteen powered barges.

Richard Hodgson, its proprietor from 1845, was a leading Liberal in the town and a supporter of the Mechanics' Institute. He nevertheless ardently opposed trade unionism, as was demonstrated in the bitter strike that erupted in May 1890 when seventy-five of his employees, who were members of the Dockers' Union, were dismissed. That was immediately followed by sympathetic action in Hull, where dockers refused to handle material destined for the tannery and seamen refused

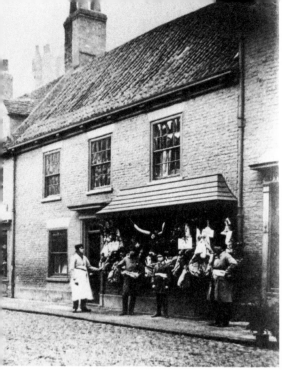

The tannery in the 1950s.

to carry Hodgson's products. Hodgson's refused any concessions and the strike collapsed in September 1890.

The longest lasting of Hodgson's rivals was Cussons's. The tannery in Keldgate had been acquired by George Cussons in 1834 and was worked by the Cussons family until *c.* 1910. It was sold to Hodgson's in 1915 and after a period of disuse was later revived.

An extract of the 1937 film of the company, *The Romance of Leather*, can be found on the vegleatherhub website (vegleatherhub.com), which describes life at Hodgson's for a former employee there in the 1960s, Michael Redwood, director of Joseph Clayton and Sons of Chesterfield: 'I first worked at Hodgson as a student in 1966 and it was very much as per the film, except that in black and white it looks darker and more gloomy than the large open factory I worked through while studying leather at Leeds University. Hodgsons was an enormous factory and the lime yard was bright with white lime and many pits. The tan yard was just immense, having an enormous crane overhead with which we moved the hides from pit to pit as required.

It is easily forgotten how much the UK changed between 1775 and 1820 due to the combined effect of the enclosures, the building of toll roads and the Industrial Revolution. In that period alone the number of licensed carriages jumped from 18,000 to 106,000, creating a massive demand for harness and saddle leathers. As such, the Richard Hodgson tannery began in 1812 in Flemingate, industrialising what had been a long history of tanning in the area using local cattle hides and oak bark. As well as equestrian leathers, Hodgson soon specialised in leather for the textile industry, used in carding, combing and condensing machinery along with belting leather needed for power transmission systems based on water and wind at first, and later for steam-driven equipment. These leathers were still being made in 1937 and most were still

in production in the 1960s when I started. Belting leathers, hair on butts and strap butts were all being made. In the heavy leather yard at Hodgson we were given clogs to wear. These had a really thick wooden sole and a hard leather upper. Sturdy socks were required to prevent chaffing, but they did keep you above the water on the floor and were far more healthy than Wellington boots. They were heavy, though, so when I fell into a lime pit it was quite a struggle to get out and rush to the showers before the sulphide did too much harm. The film says everyone fell into a tan pit, but we avoided that like the plague as a strong tan liquor is very viscous and in a deep pit it was hard to get out on your own – you sank and someone had to hook you out.

In 1920, Barrow, Hepburn and Gale went public, and promptly acquired Richard Hodgson and Sons Ltd. Hodgson's itself diversified into the manufacture of colloids for the rayon industry and in 1964 began the production of leather for shoe uppers and clothing. It continued growing and expanding through acquisition in the late 1960s and early 1970s. Yet in just a few years the global threats of cheaper labour and synthetic materials had made their marks and Barrow, Hepburn & Gale closed most of its departments in Beverley in 1978, with 750 redundancies, leaving only the chemical works in operation. In 1986 the Beverley tanning industry was finally brought to an end with the closure of Melrose Tanners, which had worked the Keldgate tannery, formerly belonging to the Cussons family and since 1946 by the Booth Group'.

Hospitals

The name reveals the primary function of the medieval hospital. Hospitality is derived from the Latin *hospitalis*, related to *hospites*, the word for 'guests', and guests were, and are, anyone who needed shelter. There were at least 700 hospitals in medieval England. After London, York had the most hospitals of any town or city, and York's St Leonard's was the biggest hospital in the kingdom.

These hospitals were very different from what we recognise as a hospital nowadays. Patient care there was, but not as we know it. They had few, if any, professionally trained doctors or surgeons, and anything approaching medical treatment was seldom offered. Medical intervention was seen by many as meddling with the will of God. Indeed, people with seemingly incurable or contagious diseases were often refused entry.

There were four main types of institutions for the poor and sick: leper houses, hostels for pilgrims, institutions for the sick poor, and almshouses. They were variously called hospitals, *maisons dieu*, massardews, or bedehouses. What they all have in common was a religious ambience and spiritual care. As such, it was always very hard to distinguish between hospitals and houses of religion – churches or abbeys. Many medieval hospitals were founded simply to care for the poor – a shelter for those too handicapped or too old to work – whose only other option was to beg in the streets. Other hospitals took in the stranger – hostels for pilgrims and other

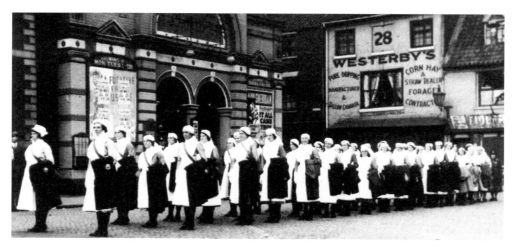

Above: St John Beverley Nursing Division in Saturday Market, ready for war work in 1940.

Below: Fox's Hospital, *c*. 1890.

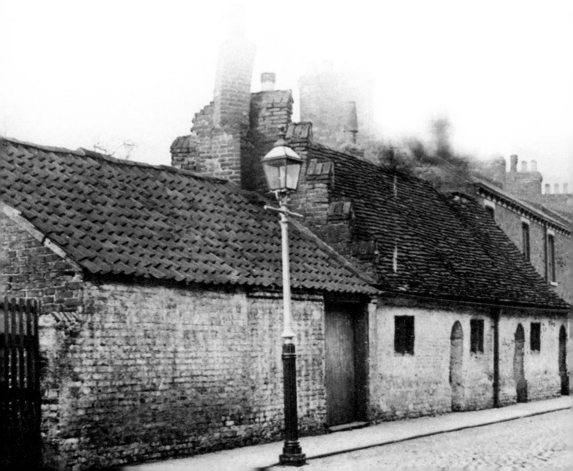

travellers. The leper houses existed to segregate the leper from society. The Church felt obligated to provide these vital charitable services if it was to fulfil its role in the world. Furthermore, they gave alms to the poor, usually from a special almonry by the gate. The hospital usually comprised a chapel and an infirmary.

In the early thirteenth century the Knights Hospitaller came to Beverley. They were an order of monks who provided hospitality to pilgrims and travellers.

Trinity Hospital was founded in Beverley in 1397. By the mid-fifteenth century there were three more: St Mary's; St John the Baptist's, west of the Wednesday Market; and St John's Hospital by Lairgate. There were also two leper hospitals: one outside Keldgate and another outside North Bar.

In 1636, the then Mayor of Beverley, Thwaites Fox, gifted a row of cottages in Minster Moorgate for use as a hospital for four poor widows. In 1823, these women received 10*s* per month plus clothing and coal, and 1*s* 8*d* from other charities. The hospital was sold in 1872 and the money transferred to the Beverley Consolidated Charities. After 1890 the cottages were demolished to make way for Jubilee Terrace.

Hull Bridge

Hull Bridge is around 1 ½ miles north-east of Beverley.

Crossing the River Hull at Hull Bridge.

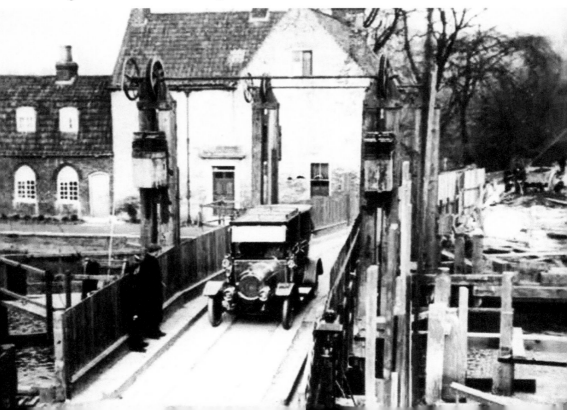

Industrial Beverley

Beverley was famous in the fifteenth century for brick and tile making. The environment and industrial pollution were issues even then. In 1461 a by-law was passed that stated 'on account of the stink, fouling of the air and destruction of fruit trees no-one is to make a kiln to make tiles in or nearer to the said town (Beverley) than the kilns that are already built'. The kilns were presumably on the outskirts of the town, but it is not known exactly where. As noted already, there was also a large leather industry in Beverley and there were many tanners. There were butchers too, who lived and worked in Butcher Row. In Beverley there were also potters and coopers.

However, medieval Beverley was most famous for its lucrative and wealth-generating cloth industry. Wool was woven in the town and it was fulled (pummelled) in water and clay to clean and thicken it. When it was dry the wool was dyed.

In 1390, a total of thirty-eight trades were mentioned in Beverley, but in the fifteenth century, like many East Yorkshire towns, Beverley went into decline, mostly because of competition from emerging towns in West Yorkshire such as Bradford and Sheffield. The population of Beverley slowly declined from around 5,000 in the Middle Ages to around 3,000 by the late seventeenth century. The cloth industry slowly declined. By the end of the seventeenth century Beverley was a market town servicing

Butcher Row.

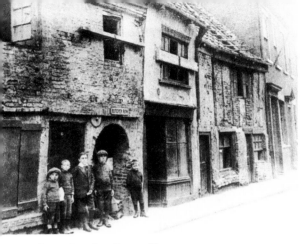

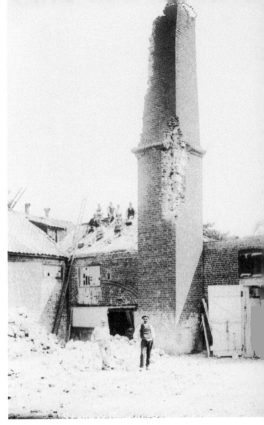

Above: Butcher Row, 1880.

Right: Queensgate Whiting works, 1910.

farm produce: millers ground grain into flour, skinners and tanners processed leather and malt and hops were brewed for ale. In the early eighteenth century Daniel Defoe visited Beverley and said that there was 'no considerable manufacture carried on there'. Later in the century there was some shipbuilding in Beverley and some brick making.

By the nineteenth century there was significant steel industry, tanning, local agricultural business and a reliance on a share of the industrial business of Hull made possible by the Beverley Beck and a waterfront along the River Hull. This Hull trade relied heavily on the inland navigation on the Ouse and Trent waterway systems, and, thanks to the Beck and the River Hull, Beverley was connected to those systems.

The 1851 census is revealing in that it shows a concentration of a number of occupational groups in Beverley that are particularly significant when they are compared with those in Hull, which had a population nearly ten times bigger than that of Beverley. There were thirty-eight tanners in Beverley, compared with ninety-seven in Hull, fifty-two wheelwrights (compared to forty-nine), fifty-two blacksmiths (309), thirty-seven whitesmiths (ninety-six), twenty-two millwrights (seventy-nine), forty-four engine and machine workers (317), and twenty-eight in iron manufacture (105). The returns also show that the town, because of its largely pleasant and leafy ambience, attracted a professional, wealthy population. There were sixteen doctors in Beverley, compared with 107 in Hull, fifty-seven schoolteachers (267), eighty-seven proprietors of houses or land (364), and 150 recipients of annuities of either sex (703).

The 1901 census provided numbers, in grouped occupations, for municipal boroughs. In Beverley there were 165 men in engineering, 476 tanners, 116 in woodworking other than housebuilding, and, among the women, 689 domestic servants and 236 milliners. Shipbuilding was not listed separately.

The ending of the age of sail in the late nineteenth century brought with it a sharp decline in the market for traditional rope rigging, and the introduction of steel cable exacerbated its demise still further.

Halls Barton Ropery Co. Ltd, rope manufacturers, saw the need to engage in wire rope manufacture and began this in 1891 when they purchased Overton Brothers's wire rope works in Beverley. The firm closed in 1993.

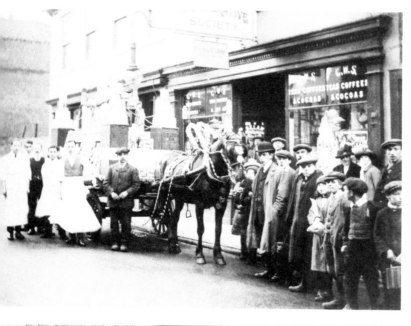

Beverley Co-op.

Gibson's the grocers, Minster Moorgate, 1905.

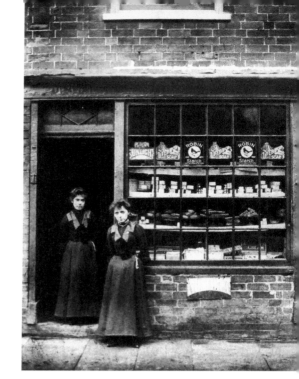

Right: Meadley's, Flemingate, *c.* 1900.

Below: Workers at Overtons Bros, wire rope manufacturers, *c.* 1940.

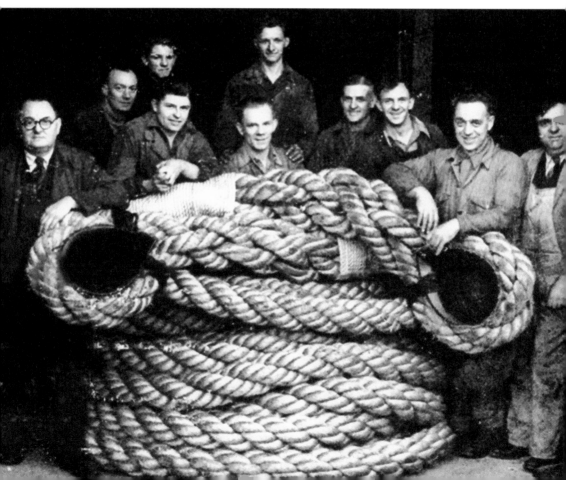

(St) John of Beverley

John of Beverley (d. 7 May 721) came to the area and founded the town where he set up a monastery. He was educated at Canterbury under Adrian and was a member of the Whitby community, under St Hilda, as recorded by his friend Bede. He was a renowned preacher. In 687 he was consecrated bishop of Hexham and in 705 was promoted to the bishopric of York. He ordained Bede as a deacon and as a priest. John was canonised by the Catholic Church in 1037. Numerous miracles of healing are ascribed to John. The popularity of his cult rubbed off on Beverley and was a cardinal factor in its prosperity due to the St John-inspired 'tourist industry' during the Middle Ages.

Henry V credited his victory at Agincourt to the miraculous intervention of John. On the day of the battle, blood and oil were seen running from his tomb. Henry made John one of the patrons of the royal household and ordered that his feast was to be celebrated throughout England. Henry and his queen visited Beverley in 1420 to make offerings at the saint's shrine. Henry VIII, however, ordered the shrine be destroyed in 1541.

Kiplingcotes Derby

Kiplingcotes Derby is widely accepted to be the oldest annual horse race in the English sporting calendar. It is run at Kiplincotes, near Market Weighton. It began in 1519 and takes place on the third Thursday in March, often in very bad weather. The 499th race was due to take place on 15 March 2018, but was cancelled due to a dangerously waterlogged course with deep, water-filled wheel ruts. During the severe winter of 1947 no one was brave enough to take part, and so one local farmer led a lone horse around the course, ensuring that the historic race would survive. During the 2001 UK foot-and-mouth crisis the race was once again reduced to one horse and rider.

One oddity in the ancient rules means the second place rider often receives more in prize money than the winner. It is not run over a typical modern racecourse: it starts near to the former Kiplingcotes railway station and finishes at Londesborough Wold Farm. A clerk is paid 5s annually for maintaining the course.

Rules
The course takes in four miles of arduous farm track and field.
Riders must weigh in at ten stones (excluding saddle).
Horses of any age can be ridden.
All those wishing to enter must gather by the starting post by 11 on the morning of the Derby.
The winner receives the sum of £50, but the rider finishing second receives the remainder of the total of the entry fees.
If the race is not run one year, then it must never be run again.

Knights Hospitaller

A preceptory (a community of the Knights Templar or Knights Hospitaller that lived on one of the order's estates in the charge of its preceptor) was established at Beverley in *c.* 1201 when Sybil de Vallines, second wife of the 3rd Lord Percy, gave to the order

the manor of Holy Trinity, east of Beverley (near the site of the railway station), the manor of North Burton and other lands.

At the dissolution in 1540, the Beverley preceptory was one of the wealthiest in England. Sadly, much of the site was buried by the construction of the Hull–Bridlington Railway in the 1840s. The north and east sides of the enclosing moat were still visible in 1856 and the east arm, eventually filled in to make way for sidings, is shown on an OS 1:500 plan of 1892. No remains of the site are now visible above ground. The preceptory complex included residential and service buildings, a church and a burial ground, enclosed by a moat and entered by a formal gateway.

The Knights Hospitaller, or Hospitallers, are also known as the Order of Knights of the Hospital of St John of Jerusalem, the Order of St John and the Order of Hospitallers. It was a Catholic military order with headquarters in the Kingdom of Jerusalem, Rhodes, Malta and St Petersburg.

The Hospitallers have their origins in the early eleventh century as a group of individuals associated with an Amalfitan hospital in the Muristan district of Jerusalem, dedicated to John the Baptist and founded around 1023 by Gerard Thom to provide care for sick, poor or injured pilgrims coming to the Holy Land. After the conquest of Jerusalem in 1099 during the First Crusade, the organisation became a religious and military order under its own papal charter, charged with the care and defence of the Holy Land.

Today the Knights Hospitaller is an ecumenical, international, Christian organisation. Their best known organisations are the St John Ambulance Brigade and the Saint John Eye Hospital in Jerusalem.

L

The Leven Carr Poisoning, 1871

Assumption of guilt based on little or no real evidence must have been the death of many an innocent suspect. The case of nineteen-year-old Hannah Bromby and her brush with the gallows illustrates this well in Leven Carr, near Beverley. On 19 May 1871, the bodies of Matilda Harper, aged fifty, and her four-year-old granddaughter Lilly Taylor were removed from Harper's farm – both had been poisoned. Servant girl Bromby was the chief suspect. She was accused of pouring red lead into the stream which served the farm. A kettle was seen to froth and Matilda Harper complained of feeling sick after drinking water from the pump. When his wife and granddaughter died, Mr Harper concluded that Bromby was the killer and accused her of poisoning them with arsenic.

The problem for Bromby was that Harper wielded power and influence locally; Bromby had neither. The common factor in the deaths was tea, which was drunk by the two deceased and a farm labourer, Henry Dunn, who also exhibited symptoms of arsenic poisoning. Bromby had made the tea, so she was arrested on a charge of murder. The victims' organs revealed the presence of arsenic, as did water from the kettle used to brew the tea. The pump water was clear, but vomit found outside from Mrs Harper contained arsenic. A complicating factor, though, for the prosecution was that Bromby had been told to fill the kettle from the stream rather than the pump because of the froth coming from the kettle. In the end, there was no real evidence to convict Bromby – just assumptions. The case was dropped until such time as new evidence might emerge.

Longcroft School and the Longcroft Gospel Choir

Beverley Longcroft County Secondary School, now known as Longcroft School and Sixth Form College, was officially opened in 1951. In 2001 it was accredited with the specialist status of a 'performing arts college'. The school is perhaps best known for the Longcroft Gospel Choir, which comprises students from Year 9 and above and

The choir performing in Beverley Market Square, Sunday 21 June 2015.

boasts an extensive repertoire. Over the choir's life so far it has performed at venues such as Disneyland Paris and the Apple Store on Oxford Street, London. They have released two of their own albums and have featured on a track by singer-songwriter Henry Priestman, 'purveyor of finely crafted rhyme since 1977'. The Longcroft Gospel Choir were one of twenty choirs in the UK to perform at and open the 2015 Rugby World Cup in London.

Lurk Lane

Fascinating name apart, Lurk Lane is important for the 1979–82 excavations on the south side of the minster, within the medieval collegiate precinct. They shed light on substantial parts of two successive pre-Conquest monasteries and a later succession of part-timbered halls. In fact, it is one of the largest collections of Anglo-Scandinavian finds from the north of England, excluding York.

M

Markets and the Market Cross

In a town that sports street names such as Saturday Market, Wednesday Market and Butcher Row, it almost goes without saying that markets were (and are) an important part of the local economy. When John of Beverley, the Bishop of York, died and was buried at the monastery and canonised in 1037, his place of burial became a magnet for pilgrims, some of them hoping for miraculous cures, others to worship. This, naturally, led to the development of a commercial centre that catered for these pilgrims, offering food, drink and other necessities. And so it was that markets were born around the monastery at Beverley.

In the twelfth century, the Archbishop of York, as lord of the manor, astutely saw Beverley as a business opportunity and encouraged the people 'to make a channel from the river of sufficient depth to carry barges'. This facilitated the importation of goods to and from ships on the river. The market was originally in the south of the town, in a large triangular piece of land near the minster, between Eastgate and Highgate. The market became known as the Wednesday Market.

A new marketplace was built north of the town, which took the name Saturday Market. A chapel dedicated to St Mary was built there, which became a parish church

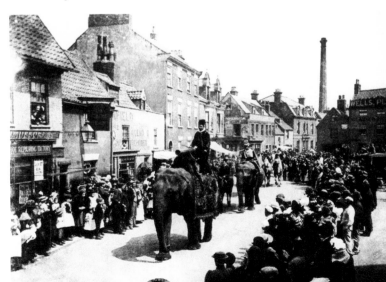

George Sanger's travelling circus comes to town. The elephants plod into the Wednesday Market, followed by a pair of camels. In 1911, Sanger was murdered with a hatchet by one of his workers, Herbert Charles Cooper.

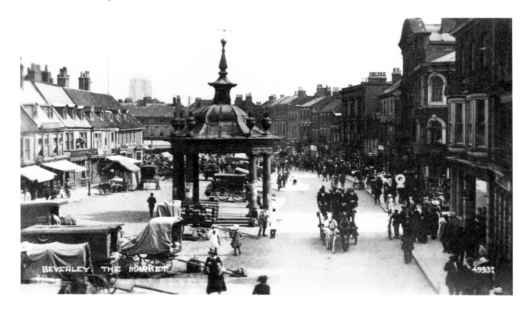

Saturday Market.

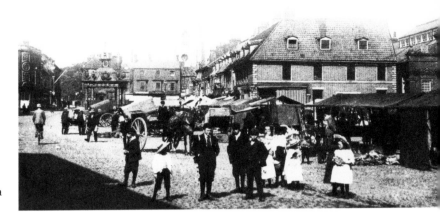

Saturday Market in the early 1900s.

in 1269. The Archbishop of York charged tolls on stallholders in these markets, with the pay point at Toll Gavel. By the end of the fourteenth century the population of Beverley was over 5,000 – a large town by the standards of the day, much larger than Hull.

In the twelfth century the Archbishop of York, as lord of the manor, was all-powerful, but over time merchants gradually increased in power and influence while the archbishop's control diminished. He built a house in the northern marketplace in the twelfth century. Initially the archbishop appointed a steward to run the town, but from the fourteenth century Beverley was run by a council of twelve keepers elected by the merchants.

When the intrepid Celia Fiennes visited the town between 1684 and around 1703 she observed, significantly, that 'the market cross is very large. There are three markets, one for beasts, another for corn and another for fish, all large'. The impressive market cross we see today was unveiled in Saturday Market in 1714 and the Corn Exchange, where grain was bought and sold, was built in 1886.

Both the Wednesday and Saturday Markets still thrive today. The impressive cross was designed by Theophilus Shelton of Wakefield and built between 1711 and 1714.

Memorial Hall and the Street Shrines of Beverley

Here is an extract from Memorial Hall's opening ceremony souvenir of 1959:

> The Hall is a memorial to the men and women of Beverley who fell in World War II and in gratitude for those who returned ... The scheme involved the acquisition of St. John's Church, Lairgate, which was consecrated in 1841 and ceased to be used for public worship in 1939. An Act of Parliament, which received the Royal Assent on the 23rd May, 1950, deconsecrated the Church and paved the way for its adaptation in two stages – one in 1954 and the other in 1959.

Today it is a thriving community venue holding all manner of social events.

Other rolls of honour and street shrines have been erected on Beckside, Flemingate, Grovehill Road, Holmechurch Lane and Norwood. These are not records of the fallen, but of those from the surrounding streets who joined up in the forces in the First World War. Some indeed were killed subsequently, which makes the survival of these 'shrines' important and unusual – most towns have lost theirs. Such street shrines seem to have been restricted to the East End of London, Hull and Beverley, and were made by working-class communities with nothing to do with the government.

Over 430 Beverley men were killed in action and there were an additional 1,000 casualties (at least) who came home with terrible life-changing wounds – physical and psychological. They came home to a country ill-equipped to deal with such disabilities and with very little knowledge of post-trauma psychiatric treatment. And it was not just the actual wounded who were implicated – for every one of these heroes a family often had to commit their lives to the full-time care of their loved ones. The Hengate War Memorial lists many, but not all, of the fallen.

Museum of Army Transport

This was a wonderful museum of British Army vehicles, many of which were part of the National Army Museum, as well as railway locomotives, rolling stock and the only remaining Blackburn Beverley, aircraft XB259.

The Blackburn B-101 Beverley was a 1950s British heavy transport aircraft built by Blackburn and General Aircraft and flown by squadrons of the Royal Air Force Transport Command from 1957 until 1967. The Beverley was equipped with toilets, which were situated in the tail beyond the paratroop hatch located on the floor of the tail boom. One fatality was caused by a serviceman who fell 20 feet to the ground when exiting the toilet, unaware that the paratroop hatch had been opened. Modifications

Blackburn Beverley (XB287) in 1964. (Courtesy of Adrian Pingstone under Creative Commons)

were made to prevent the toilet doors from being opened when the paratroop hatch was open. In total, forty-nine of the aircraft were produced. Beverley's Beverley is now at Fort Paull Museum, Armouries and Visitors Centre, east of Hull.

Sadly, the Museum of Army Transport went into administration after it was faced with a £140,000 repair bill for its roof, closing in 2003.

Above: The tiny 0-4-2T, *Gazelle*, in 1995, which was used on the Shropshire & Montgomeryshire Railway in its military days. When the Museum of Army Transport closed, *Gazelle* was taken into the care of the Colonel Stephens Railway Museum. (Courtesy of Ben Brooksbank under Creative Commons)

Right: A Mastiff protective patrol vehicle (the British variant of the US Cougar) at the Defence School of Transport, 2010. (Courtesy of Turbojo under Creative Commons)

Nellie's (The White Horse Inn)

From the excellent website (not associated with the pub's owners, management or staff): 'Please note: DOGS (with the exception of registered guide, or other assistive dogs), monkeys, any reptiles, ferrets, or fruit bats, are currently NOT allowed inside the premises. Thank you for your understanding.' This is not as daft as it sounds, however. The pub is a favourite haunt of hundreds of Hull's university students every weekend in term time, so anything can happen here.

Officially The White Horse in Hengate, it acquired the name 'Nellie's' from the days before 1976 when the pub was owned and run by the Collinson family. Francis Collinson bought the pub from the church in 1927 and her daughter Nellie managed the pub until its sale to Samuel Smiths Old Brewery of Tadcaster. Nellie's lover was known as 'Suitcase Johnny', so named because of the frequency with which Nellie kicked him out.

Nellie's was originally a coaching inn, thriving even before 1666. It is the second oldest surviving inn in Beverley, after *The Sun Inn*, opposite Beverley Minster.

Nellie's famously clings onto most of its original seventeenth-century features, including gas lights and chandeliers; small, intimate rooms; rickety stone and wooden floors; equally rickety chairs (I remember sitting on upturned barrels in the '70s, the very ones from which the beer was drawn by Nelly and her sisters); marble-topped tables; really old real books; vintage photographs; old, blurry, mottled mirrors; and (real burning) open fires. The 'tobacco-stained' walls are lovingly painted a filthy brown to faithfully recreate the tangible nicotine of those hazy pre-health-and-safety days of laissez-faire attitudes – probably the only instance of artifice in the place.

The (original) well is in the entrance yard – sensibly gate-locked, as 20-foot-deep wells and alcohol make for an unwise cocktail. A few years ago, regular customer Jonathan Linthwhaite – Johnny Windows to you and I – spent some quality time (reputedly twenty-four hours) down the well in aid of charity. Johnny was 'a big lad' so there was little room for manoeuvre – draw your own conclusions about personal hygiene and natural needs. The tedium was relieved a bit by free-flowing showers of projectile alcohol during opening hours.

There is still a linen-press room – complete with working press and a scullery with a glass-fronted wall enveloping a selection of receipts and invoices from local

businesses – dating back to the turn of the nineteenth to twentieth century. What was the non-smoking room has had its gas lights restored with real gas mantles – candles flickered away quite safely in the intervening period. The family room (or Dart Room) boasts a well-used piano and an authentic old wine-cooling chest, and a dartboard, of course. The main bar is a no-children zone and has a bar – before the Sam Smith Age, which ushered in relative modernity, there was no bar and drinks were served on tables scattered around the room. The wall clock is consistently wrong both in time and chime. Unlikey as it seems, Sam Smith's modernised the place in 1976, installing its first bar.

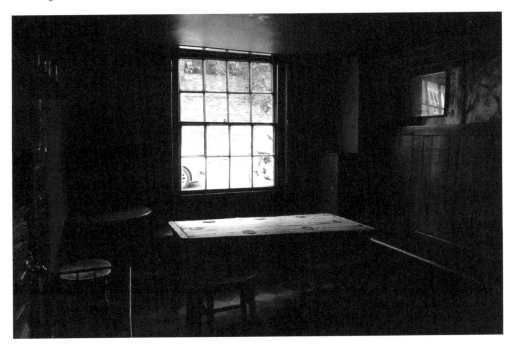

Above and right: Inside Nellie's, 2018.

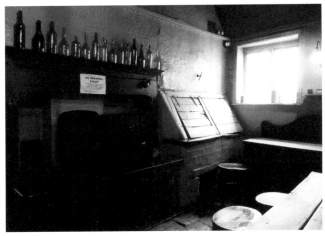

The Old Fund

The preservation of Beverley Minster is organised differently from similar such buildings. Unusually for an Anglican church, the onus for repairing and maintaining the fabric of the minster – the stone, timber, glass and lead – is not with the Parochial Church Council but with the Beverley Minster Old Fund, an ancient charity established in 1579.

It was originally called Queen Elizabeth's Church Endowment as Elizabeth I granted letters patent under the great seal of England, giving 'chauntries, lands and tenements' for the sole purpose of repairing and maintaining the fabric of the minster. This was not as generous as it sounded; in fact, it was nothing short of payback for the depredations of her predecessors Henry VIII and Edward VI who confiscated significant assets of land and property from the minster during the Reformation.

The fund receives no help from official sources. Its income is derived entirely from investments, legacies and donations. When Sir Michael Warton died in 1725 he left a substantial amount of money in his will – £4,500 – for the repair and maintenance of the minster. This was the 'New Fund', which was amalgamated with the 'Old Fund' in 1882; the Old Fund still operates today, maintaining the fabric of the minster.

P

Frederick Parker and His Hedge Stake, 1868

The first thing you could do when released from Beverley jail was to go into the Red Lion for a pint or two. That is what Frederick Parker, a bricklayer all the way from Tottenham, did. Daniel Driscoll, from near Selby, did the same, and the two ex-convicts got drunk together on a pub crawl that ended in Bubwith, 18 miles from Beverley. Tactlessly, Driscoll disclosed that he was carrying over £4 on him. Parker, forgetting anything he had been told about the rehabilitation of offenders, acted on this information by beating Driscoll on the head with a hedge stake and relieved him of the £4 and his watch, and his life. Parker was the last man to publically hang in York.

Pilgrimage of Grace

Henry VIII had enough domestic and ecclesiastical issues to deal with without the turbulence of the Pilgrimage of Grace. This was a popular revolt that began in Yorkshire in 1536 under the leadership of barrister Robert Aske, before spreading to other parts of northern England. The 'most serious of all Tudor rebellions', it was a 40,000-strong protest against Henry VIII's schism with the Roman Catholic Church, the Dissolution of the Monasteries and the policies of the king's chief minister, Thomas Cromwell, along with other political, social and economic grievances.

Monks expelled from religious houses led a revolt from Beverley in October 1536, which became known as the Pilgrimage of Grace. Aske headed a band of 9,000 acolytes who occupied York. He instructed expelled monks and nuns to return to their religious houses; the king's newly installed tenants were driven out and Catholic observances were resumed.

In the end, a royal pardon brought the rebellion to an end, but a resurgence of violence in the new year shattered the fragile peace. Aske was arrested on new charges of treason and was sent back to York for execution. He was hanged from Clifford's Tower on 12 July 1537. Predictably, the wider reprisals were brutal and extensive.

Population

By the late fourteenth century the population of Beverley had risen to over 5,000, a reflection largely of the notoriety engendered by the pilgrims to the shrine of St John and the town's substantial wool and textile industry.

The population of Beverley declined from around 5,000 in the Middle Ages to approximately 3,000 by the late seventeenth century, indicative of the decline of the woollen industry. By 1770 the population of Beverley had recovered to around 4,000.

In 1801, at the time of the first census, Beverley had a population of 5,401 – roughly the same as it had been 400 years before. By 1831 it had reached approximately 7,400, and by 1871 it was around 10,200.

Nineteenth-century Beverley's population was growing, but slowly. Numbers rose from 5,401 in 1801 to 8,915 in 1851 and 13,654 by 1911. This was a lower rate of growth than for the United Kingdom as a whole, which approximately doubled between 1801 and 1851, and doubled again by 1914. Part of this can be explained by substantial emigration from Beverley initially into Hull and also overseas. In 1906 the Beverley Emigration Society reported plans to send a group of fifty or so men to Canada every year, and a party of fifty left the next month.

By 1951 the population had risen to around 15,500. According to the 2001 census the total population of the urban area of Beverley was 29,110 – of whom 17,549 live within the historic parish boundaries. The population of the parish had risen to 18,624 at the time of the 2011 census.

Public and Civic Amenities and Public Health

In the fifteenth century, as with many East Yorkshire towns, Beverley went into decline, mostly because of competition from emerging towns in West Yorkshire, such as Bradford and Sheffield.

By the 1530s Beverley had declined significantly from its zenith in the Middle Ages. The decline was clearly visible: one visitor said it had 'diverse and many houses and tenements in great ruin and decay'. Another visitor said there had been 'good cloth making at Beverley but that is now much decayed'.

In the Middle Ages many people believed their sins would be absolved if they embarked on an arduous and challenging pilgrimage. Protestants rejected this teaching, however. When England became a Protestant country pilgrimages ended, which dealt a serious blow to Beverley's lucrative 'tourist' industry. In the 1530s Henry VIII closed the friaries in Beverley. He also dissolved the holding of the Knights Hospitaller, and the hospitals were also closed.

The opening of Lord Roberts Road – named after Lord Frederick Roberts 1832–1914, hero of the South African War. Field Marshal Frederick Sleigh Roberts, 1st Earl Roberts, VC, KG, KP, GCB, OM, GCSI, GCIE, KStJ, VD, PC (1832–1914) was one of the most successful commanders of the nineteenth century. He served in the Indian Rebellion, the Expedition to Abyssinia and the Second Anglo-Afghan War before leading British Forces to success in the Second Boer War.

Beverley Gas Works, Old Hull Road, 1910.

Above: Beverley Borough Fire Brigade, 1911.

Below: Refuse collector, *c.* 1940.

At the end of the sixteenth century Beverley was still languishing in poverty. In 1599 it was described as being 'very poor and greatly depopulated'. There were 'four hundred tenements and dwelling houses utterly decayed and uninhabited besides so great a number of poor and needy people altogether unable so to be employed any way to get their own living'.

By the end of the seventeenth century there was a slight economic upturn in the town, but Beverley was no longer the major manufacturing centre it once was.

After 1809 Beverley was lit by oil lamps, and from 1824 it was illuminated by gas. Communications and transportation improved dramatically when a railway to Hull was built in 1846.

Beverley was comparatively slow in adopting or receiving modern facilities. A piped water supply began in 1883, but there were no sewers until after 1889. Even then it was decades before everyone was connected. The absence of good sanitation in the town fostered epidemics. A cottage hospital was built in 1876, but there was an outbreak of typhoid in Beverley in 1884. Digging sewers and creating a piped water supply finally improved the public health situation. However, there was no electric street lighting until immediately after the Second World War. There was no electricity in homes until 1930 and in the 1930s only around half of the dwellings in Beverley had flushing lavatories, a situation only remedied in 1960.

The first public library in Beverley opened its doors in 1906. A museum and art gallery followed in 1910. The first cinema opened in Beverley in 1912.

The Push Inn

There were pubs aplenty in Beverley. Records for the Push go back to 1717. In later years it became the shop of apothecary and spirit merchant James Mowld Robinson. According to Jan Crowther in her *Beverley in Mid-Victorian Times*:

> ...and surely the most versatile of all – James Mowld Robinson, who was a maltster, sold wines and spirits, brewed beer, both for consumption off and on the premises, dispensed medicines and operated as a surgeon, acted as an insurance agent, and sold corn. In 1851 Robinson lived over the shop, but by 1867 he had moved to a more elevated address in North Bar Without.

The name 'Push Inn' was apparently taken from a sign on a door of the inn and has become its official name – better to push in than to be pushed out. It is reminiscent of other humorously named inns such as The Nobody Inn in Doddiscombsleigh and in Grantham.

Some of Beverley's lost pubs (as recorded on closedpubs.co.uk/yorkshire/beverley) include:

Admiral Duncan Inn, also known as the Hallgarth Inn, Hallgarth, Beverley Parks, closed 1896
Anchor Inn, Beckside
Beehive, Keldgate
Black Swan, Highgate
Buck Inn, closed *c.* 1999, No. 25 Beckside
Drovers Arms, closed 1999, Corporation Road
George & Dragon, Highgate
Globe Inn, Ladygate
Kings Arms, North Bar Street
Lady Le Gros, Norwood
Lincoln Arms, Lincoln Way
Malt Shovel, Walkergate
Mariners Arms, Beckside
Monks Walk, Highgate – now reopened
Nags Head, Grove Hill
Oddfellows Arms, closed 2013, No. 2 Trinity Lane
Pack Horse, Market Place
Red Lion, Toll Gavel
Ship Inn, Market Place
Telegraph, Railway Street
Travellers Rest, No. 36 Beckside
Valiant Soldier, Norwood – now reopened as The Cornerhouse
Victoria, Victoria Road
White Swan, Market Place.

Behind the Globe Inn was Globe Inn Yard, which contained many cottages and was accessed through the archway from Ladygate. The landlord of the Globe owned it and was used for the Beverley pig market during the middle of the nineteenth century, as well as a cock pit. The pub was closed in 1963 and demolished in 1968 to allow a road linking Sow Hill and Walkergate.

Records for the Pack Horse go back to 1784. The name 'Pack Horse' often denotes that the inn was a posting inn. It also sheds light on the pub's age: before the introduction of carts and wagons towards the end of the seventeenth century pack horses were one of the few means of transporting goods overland.

We hear from the *Rambler* in 1939 that 'the Malt Shovel was at one time prominently embellished by a Malster's shovel in the front of the licensed house in Walkergate bearing that name'. It was a John Smith & Co. house. The pub closed in the early 1940s and the building was demolished many years later for the New Walkergate development in 1967.

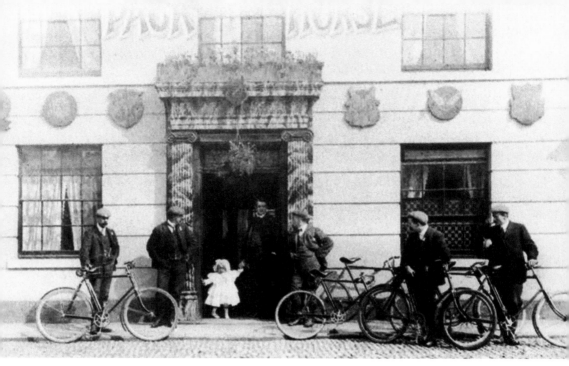

Above: The Pack Horse Inn, *c.* 1910.

Below left: The George & Dragon, *c.* 1910.

Below right: The Malt Shovel, Walkergate, *c.* 1900.

Quakers

In 1651, George Fox came to Beverley to preach the Quaker faith. In the 1660s Quakers established a meeting house here and have worshipped in Beverley ever since. Their present meeting house – their third – in Quaker Lane was built in 1961.

Until the 1870s, Friends were excluded by the 1673 Test Act from Oxford and Cambridge because of their nonconformism and the universities' ties with Anglicanism. The Act also debarred them from public office and from Parliament, and to some extent the guilds; medicine was only accessible via an apprenticeship to an apothecary; they were restricted in what they could and could not do as lawyers because they refused to take oaths; the arts were considered by many as frivolous; and Quakers were disqualified from the armed services because they were largely pacifists. Consequently, one of the few options left to privileged and well-to-do young Quakers was to follow a life in industry or business, and this is what people like Joseph Rowntree of York, the Reckitts and Priestmans, both of Hull, and many others did. They often brought with them a tradition of high-quality management and ethical trading practices, rigorous scientific research and innovative technical development, as well as an almost obsessive preoccupation with quality and a breathtakingly detailed attention to business administration.

One of the legacies of the frequent meetings routinely held by the Society of Friends, and the travelling required to get to these meetings, was the building up of a strong network of dependable friends and contacts. This, in turn, along with intermarriage among Quaker families, led to a tradition of mutual assistance in business and industry, and to strong business networks and industrial partnerships.

When Fox came to Beverley he 'declared truth to the priest and people' in the minster. Beverley is notable in that he received a good and sympathetic reception here, receiving him relatively sympathetically. He was not, for example, shoved down the steps of the minster as he was in York. Joseph Wilson, the vicar of St Mary's, showed interest in what he had to say and he was made very welcome supported by the local magistrate, Justice Hotham.

Fox's visit led to a small group of Quakers begin meeting in their houses in the town. Nonconformist worship was, of course, illegal, and attending meetings ran the

risk of prosecution and persecution. What's more, Quaker beliefs led them to refuse to pay tithes or attend the established church. Many were assaulted and abused and, when hauled before the justices, had their goods and homes confiscated or were subjected to lengthy spells in prison, where some actually died. In 1661, Elizabeth Dawson, Elizabeth Brown, Jeremy Burton and Christopher Wetherill were sent to prison for attending a religious meeting at Thomas Hutchinson's house in Beverley. The passing of the Toleration Act in 1689, after much lobbying, saw 15,000 Quakers released from prison.

The Racecourse

Beverley Racecourse has been part Beverley life for over 300 years – we know that a permanent track existed in Beverley as early as 1690 on Westwood and Hurn meadows. The first Grandstand was built in 1767, and an annual meeting at Beverley was first established that same year. The cost of the stand was £1,000, funded by money raised from the sale of 300 silver admission tickets, which gained free entrance for life for its subscriber.

In 1813, Squire Watt of Bishop Burton bred and trained numerous winners, including the St Leger winners Altisidora, Barefoot, Memnon and Rockingham. The great Blink Bonny won a two-year-old race at Beverley in 1856, before winning both the Derby and the Oaks the next year. Later in the nineteenth century there was an annual three-day meeting in the week after York's May meeting.

The racecourse is a right-handed flat course, just over 1 mile long (3 furlongs). It is mainly flat but with a pronounced uphill finish and tight turns. Beverley has the most pronounced 'draw bias' on a UK racecourse on its 5 furlong course. Currently the course hosts nineteen meetings annually.

A recent meeting at Beverley Racecourse. (Courtesy of Kate Mckee, marketing manager at Beverley Racecourse)

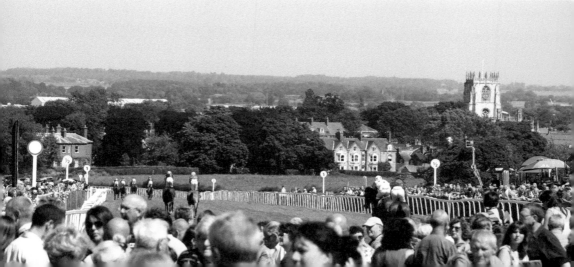

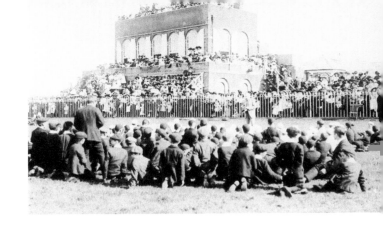

The scene in 1911.

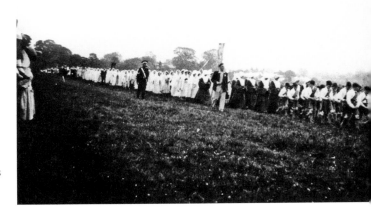

The canonisation of Sir Thomas
More and John Fisher on the
racecourse in 1935.

Railways

In 1848, Hull Paragon station opened and the Selby opened as did the Selby and Market Weighton link. With the line to Beverley following some years later. This opened up all sorts of opportunities for industry and tourism. For example, before Harrogate was established as the regular venue for the Great Yorkshire Show, the Royal Agricultural Society and the Yorkshire Agriculture Society held it in different Yorkshire towns – Beverley, Richmond, Doncaster and Leeds – and, for the third time, York in 1848.

Beverley station was opened in October 1846 by the York and North Midland Railway-leased Bridlington branch of the Hull and Selby Railway. The original station was designed by famous railway architect G. T. Andrews.

Beverley was elevated to junction status in 1865 when the North Eastern Railway completed the Market Weighton to Beverley section of the York to Beverley line. The station was also planned to be the junction for the North Holderness Light Railway, but NER never built the line. The York to Beverley line closed as a result of the Beeching Axe on 29 November 1965.

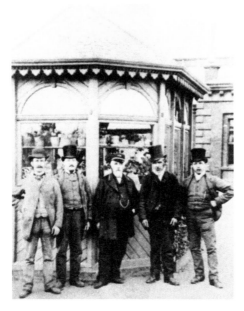

The cabbies' shelter outside the station in 1890. Local authorities established the shelters to relieve the problem of the cabbies resorting to pubs to find warmth and refreshment.

Beverley railway station, *c.* 1900.

The footbridge over the railway near Armstrong Way, 1911.

An S&R Sea King from RAF Leconfield, 26 June 2010. (Courtesy of Gareth Davies)

RAF Leconfield

The site of the former Royal Air Force Station Leconfield (also known as RAF Leconfield or Leconfield Camp) is now used by the MoD Defence School of Transport.

Leconfield opened in December 1936 as part of RAF Bomber Command, flying Handley Page Heyford bombers from 1937. On the night of 3 September 1939, the very first night of the Second World War, ten Whitley bombers from Leconfield became the first British aircraft to penetrate German airspace, dropping propaganda leaflets over Germany. In October 1939 Leconfield was taken over by Fighter Command flying Spitfires of 72 Squadron from RAF Church Fenton. During the Battle of Britain there was also a decoy airfield at nearby Routh.

During the war the RAF squadrons stationed at Leconfield were 51 Squadron, 166 Squadron, 196 Squadron, 466 Squadron, 610 Squadron and 640 Squadron.

In the 1950s Leconfield became a 'dispersal base' for the RAF V-bomber force. It was also home to the Central Gunnery School, which trained air-gunnery instructors in Wellington bombers and pilot attack instructors in Spitfire and Mosquito aircraft. This school later became the Fighter Weapons School, flying mainly single-seat Venoms and Meteors plus twin-seat Vampire T11, Meteor trainers and Hawker Hunters for trials with ADEN cannons in 1957. Bristol Sycamore helicopters of 228 Squadron RAF arrived in 1957.

In the 1960s Leconfield was home to 19 Squadron with Hawker Hunter F.6s, then 92 Squadron with Lightning F.2s, which moved from RAF Church Fenton before their posting to RAF Gütersloh in West Germany in 1965. It then became home to 60 Maintenance Unit and also 202 D-Flight with Wessex Whirlwind helicopters. Responsible for the major servicing of the EE/BAC Lightnings was 60 MU, and 202 Squadron became the first SAR unit to rescue people off of Britain's first offshore oil rig, *Sea Gem*. The rig had capsized on 27 December 1965 and the crew of a Whirlwind rescued three men from the freezing water in a violent snowstorm.

Flying operations ended on 1 April 2015 with the departure of the two Sea King helicopters. The search and rescue function has been assumed by the Maritime and Coastguard agency based at Humberside Airport.

The Salvation Army Citadel

The photo shows a Salvation Army Citadel group on Wilbert Lane sometime between 1917 and 1920. This citadel was built in 1886 on Wilbert Lane to replace several temporary meeting places in the town. It could hold 1,200 people. The billboards announce 'The Bolshevist is coming' and 'Envoy Fred Kendall coming to Beverley'. The Russian Revolution had recently taken place.

 The citadel was closed in 1985 and later demolished, with meetings subsequently held in the former Methodist Sunday School on Walkergate.

A rather militant-looking demonstration outside the citadel in 1917.

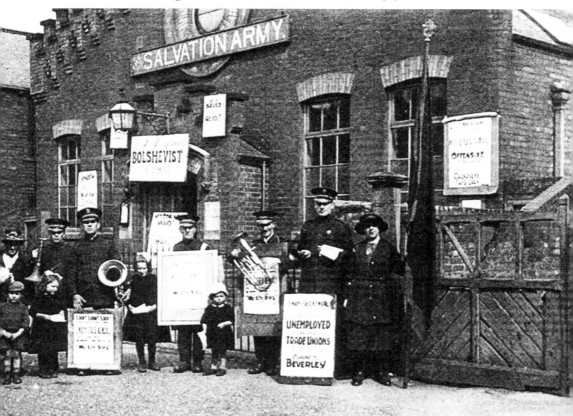

Sessions House

From 1810, the East Riding Quarter Sessions were held in Sessions House, New Walk, taking over the role from the Guildhall. Sessions House was a purpose-built courthouse, designed by Watson and Pritchett of York, built next to a new East Riding House of Correction constructed at the same time. Prisoners sentenced to transportation in the courtroom here included Luke Dales, sentenced to transportation at the East Riding Quarter Sessions on 31 December 1844; Sarah Ann Sharpe, sentenced to seven years' transportation at the midsummer East Riding Quarter Sessions on 27 June 1837; and Maria Fay, convicted of theft at the East Riding Quarter Sessions on 8 April 1851.

Dales had a string of previous convictions – mainly for theft – for which he was detained in the House of Correction. He was listed as living in the parish of Leconfield. Justice Leeman sentenced him to 'be transported beyond the seas for a term of seven years' for stealing a top coat (valued at 5s) from George Arnold. Soon after his conviction in March 1845, Dales was taken to the hulk *Warrior*, which was moored on the Thames. At some point he was transported to Bermuda, where the British had established a convict colony for the purposes of providing labour for the building of a Royal Navy dockyard. Strong and healthy convicts were selected to spend some or all of their sentence here before returning home or being moved on to New South Wales or Van Diemen's Land. Dales was one of 204 male convicts loaded onto the ship *Bangalore*, which sailed from Bermuda for Van Diemen's Land on 28 March 1848 . The ship travelled via China and arrived at Hobart on 14 July 1848.

New Walk.

A report in the *Yorkshire Gazette* 1 July 1837 gives us the details about Sarah Anne Sharp:

SARAH ANN SHARPE (20 years) charged with stealing, at Brandesburton, on 24 April, one straw bonnet and a pair of cloth shoes, the property of Ann Wallace. Prisoner went to lodge at the house of prosecutrix; she stated that she had come out of Beverley jail. She remained there a week; on her going away, the bonnet and boots were missed. A Bridlington constable apprehended her with the articles in her possession. To be transported for seven years.

After time in the hulks at Woolwich, Sharpe was transported to Van Diemen's Land as one of 133 female convicts aboard the ship *Nautilus*, departing from Woolwich on 25 April 1838. The ship's surgeon reported that Sarah was aged nineteen and was a servant. She was on the ship's sick list for a month between May and June with 'gastrodynia' (a stomach complaint). Tasmanian convict records reveal that Sharpe Sarah had brown eyes, brown hair and had been a farm servant before her conviction.

St Mary's Church

'Lovely St Mary's, unequalled in England and almost without rival on the continent of Europe!' Sir Tatton Sykes, a nineteenth-century East Riding landowner and restorer of churches, said this while contemplating the west front of the church. St Mary's, admired by both Sir Nikolaus Pevsner and Sir John Betjeman, owes its magnificence to 400 years of almost continuous building from 1120 to 1530. It was regarded as the parish church of the town.

Between 1844 and 1876 a complete restoration of the church was carried out under the supervision of Augustus Welby Pugin, his son E. Welby Pugin, and then by Sir Gilbert Scott.

St Mary's was established in the first half of the twelfth century as a daughter church of Beverley Minster to serve Beverley's trading community around Saturday Market.

Disaster struck during Evensong on 29 April 1520 when the central tower collapsed 'and overwhelmed some that then were in [the church]'.

The old Flemish priests' room.

Schoolboys walking past St Mary's.

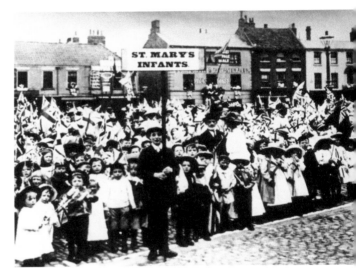

St Mary's Infant School children celebrating Victoria's Diamond Jubilee in 1899.

The window by Clayton & Bell depicting the life of St Paul at the east end of the north aisle in 2016. (Courtesy of Jules and Jenny from Lincoln)

Town Walls

In the early days of the Middle Ages, Beverley had no walls. Instead, a 'great ditch', later called Bar Dike, had been built on west side of the town by 1169, and by the thirteenth century there were two gateways to the town – North Bar and South Bar (later Keldgate Bar).

This virtual absence of security naturally made the people of Beverley nervous, so in 1322 Beverley petitioned Parliament, requesting permission to build a protective town wall. Beverley had been attacked by the Scots in 1321 during the Wars of Scottish Independence and had been ransomed from the Scots in early 1322. Nothing happened. The Archbishop of York was not interested. In 1371, prompted by the threat of war with France, a commission looked at Beverley's defences again; however, once again nothing really happened.

At the beginning of the fifteenth century, during Henry IV's reign, political instability led to measures to improve Beverley's defences. The town council rebuilt North Bar in brick between 1409 and 1410, with a portcullis and parapets. Chains were bought to block entrances and streets, other gateways were repaired with brick and iron, and additional 'bars' (long pieces of timber) were acquired to protect the entrances to the town. By the time John Leland visited in 1540, North Bar Gate, Keldgate and the recently built Newbegin Gate were all in situ in brick, but these somewhat half-hearted defences did nothing to stop rebels entering the town in 1537.

In the Civil War Beverley's defences were reinforced with new ditches, the gatehouses were refurbished and a garrison of 900 men guarded the town; however it was once again to no avail, since Royalist forces were able to successfully raid the town. After the war the defences were neglected and ditches began to be filled in as the town expanded.

U

Union Mill

Beverley Union Mill, formerly known as the Anti-mill, was a corn and flour windmill on Beverley Westwood owned by Beverley Union Mill Co. Ltd between 1804 and 1890. The Union Mill Company had bought it from a bookseller. It originally had a tall brick tower and five sails. The Union Mill Society was formed in 1799 to run a co-operative mill, and in 1800 built the Anti-mill near the south-western corner of Westwood. The society still existed in 1864, but the mill was later worked privately, probably until the 1890s. In the 1890s, when the mill fell into disuse, the upper section was dismantled. In 1906, the tower was converted into the clubhouse of the newly formed Beverley & East Riding Golf Club.

Victoria Barracks

The Beverley Volunteer Infantry occupied a storeroom in the town in 1807 and its successor, the East Riding Local Militia, formed in 1808 and disbanded in 1836, rented a storeroom from an innkeeper in 1809. The militia had an arms depot with quarters for a sergeant at the Guildhall in 1829. By 1838 the old established East York Regiment of Militia had a storeroom in Waltham Lane. After the reorganisation of the militia in 1852, that room was deemed inadequate and a depot or barracks was built in 1853–54 – the site, on the north side of the Sessions House in New Walk, had been bought by the East Riding justices in 1845.

A military parade of the East Yorkshire Regiment at the market cross on 4 March 1905. Behind them is The Push Inn on the corner.

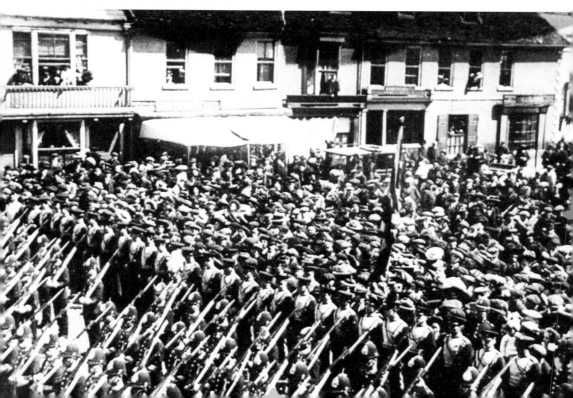

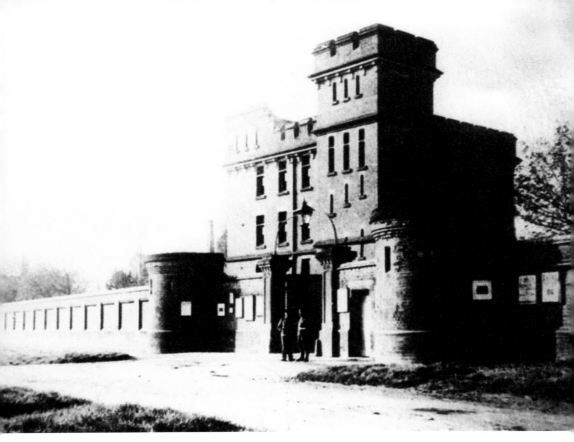

Victoria Barracks, 1940.

Victoria Barracks was built between 1877 and 1878 to serve as the depot of the two battalions of the 15th (Yorkshire East Riding) Regiment of Foot between 1877 and 1878. It was also home to the East York Militia. Following the Childers Reforms, the 15th Regiment of Foot evolved to become the East Yorkshire Regiment with its depot at the barracks in 1881.

A battalion of the East Yorkshire Volunteers, formed in 1860, had a drill hall in Walkergate in the late nineteenth century. In 1902 the former grammar school building in Albert Terrace was bought by the county council and converted to a headquarters for the volunteers, who rented it from 1904. It passed to the Territorial Army and was given up in 1946 and later used as a fire station.

During the First World War, the Victoria Barracks were extended by the construction of a large hutted camp in adjacent fields, which became Normandy Camp. In 1949 it was occupied by a Royal Signals Boys training unit. The barracks were significantly extended during the Second World War. The regiment amalgamated with the West Yorkshire Regiment to form the Prince of Wales's Own Regiment of Yorkshire in 1958. Following the closure of the barracks in 1960, the Minstry of Defence disposed of the property.

The Westwood

Beverley is blessed with four pastures on the edges of the town: east and south-east of the town, along the River Hull are the pastures of Figham and Swinemoor. To the east and south-east of the town are the Westwood and Hurn, which is one large pasture.

Chalk quarried from the Westwood was used in the foundation of Beverley's streets and for making lime. The Corporation made money from leasing out limekilns on the Westwood until 1812. Clay was used for brick making by local brick makers. The North Bar is built with Beverley-made bricks.

There is a golf course and racecourse on Westwood; it was laid out after the Beverley and East Riding Golf Club was formed in 1889. A pavilion was erected near Black Mill in 1891 and moved in 1906 to the Anti-mill, with which it formed a new clubhouse.

The pastures are looked after by the pasture masters, a group of men elected from the Freemen of Beverley each March. In 1978 the courts judged that the pastures were owned by the then borough council; it is now 'owned' by the East Riding of Yorkshire Council.

In the later nineteenth century Beverley had at least fifteen other brass bands, including Beverley Amateur Brass Band, Beverley Borough Band, Beverley Total Abstinence Band, Beverley Temperance Band, Beverley Foresters' Brass Band, Beverley Brass Band, Beverley Mechanics' Brass Band, Beverley Oddfellows' Band, Beverley Old Brass Band and Beverley Silver Brass Band.

An Avro 504K
(Scottish Aviation) on
Beverley Westwood, *c.* 1910.

Above: A cricket match on the Westwood before 1868.

Right: The TA camp on the Westwood in 1928.

Th Camp Beverley Westwood 1928

Beverley United Prize Band on the Westwood in 1910.

X-rays

The Minor Injury Units at Beverley and Bridlington have been replaced by Urgent Treatment Centres. Beverley's is at Beverley Urgent Treatment Centre, East Riding Community Hospital, Swinemoor Lane. The centres are for an urgent injury or illness that is not serious, life or limb threatening. Investigations like X-rays and blood tests can be performed as required.

Y

The Yorkshire Regiment

The 1st Battalion of the Yorkshire Regiment were welcomed back home to Beverley on 31 July 2009. A total of 1,000 people watched as the gates of North Bar were opened to allow the troops in, and a civic salute was taken at the market cross. Returning from tours in Iraq and Kosovo, the battalion was exercising its right to march through the town with drums beating, colours flying and bayonets fixed.

In 2012 and in June 2017 the parade was repeated when 100 or more troops from the 2nd Battalion approached North Bar, which was closed to them. The parade commander asked for permission to enter the town and the gates were opened by the town crier, before the parade then marched to the cross. The battalion was then deployed to Afghanistan.

Zeppelins over Beverley

Defence against Zeppelins was something of an afterthought in the earlier years of the First World War. Throughout 1915 many Yorkshire coastal towns and industrial sites were targeted. Places like Whitby, Skinningrove, Saltburn, Beverley and then Leeds and York were all targeted, often by six or ten airships, raiding more or less with impunity.

There were prosecutions of people not observing the blackout. The controversial official advice was for people to remain inside during raids – a doctor at York's Retreat Hospital circulated a letter on worrying levels of 'Zeppelinophobia'.

On 5 March 2016 the German Naval Airship Division instigated a three-Zeppelin raid on the shipyards on the Firth of Forth and a secondary target on the rivers Tyne and Tees. All three Zeppelins – L.11, L.13 and L.14 – had to deal with snowstorms and were blown off course by fierce winds.

Zeppelin L.14 came over the coast at Flamborough Head at around 10.30 p.m. At 11.25 p.m. she flew west from Barmston and dropped an incendiary bomb near the hamlet of Gembling. From there she turned south and at around midnight dropped three high-explosive and three incendiary bombs in fields at Woodmansey. From there L.14 made for Hull and, unchallenged, dropped the first of seven high-explosive bombs over the city at around 12.05 a.m. Hull had no anti-aircraft guns.

Acknowledgements

Thanks to Kate Mckee, marketing manager at Beverley Racecourse, for permission to use the photograph of a recent race meeting there.

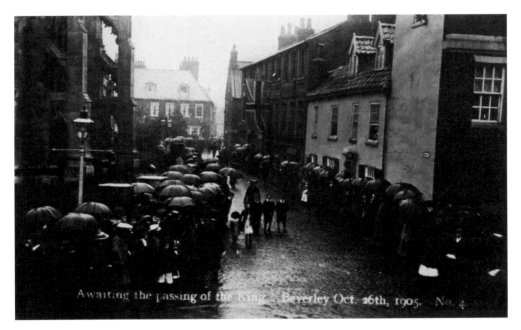

Waiting for the king in the pouring rain, 1905.

About the Author

Paul Chrystal has degrees from the universities of Hull and Southampton. In the mid-1970s he worked in the Beverley Bookshop and at what was then Bowes & Bowes Bookshop (now Waterstones) at the University of Hull. After that he was in medical publishing for forty or so years, but now combines this with writing features for national newspapers and history magazines, as well as appearing regularly on BBC local radio, on the BBC World Service and Radio 4's PM programme. Paul has also contributed to a forthcoming six-part series for BBC2 'celebrating the history of some of Britain's most iconic craft industries' – in this case chocolate in York. He has been history advisor for a number of York tourist attractions and is the author of 100 or so books on a wide range of subjects. From 2019 he takes over the editorship of *York Historian*, the journal of the Yorkshire Architectural and York Archaeological Society. Paul now lives near York. In 2019 he is also guest speaker for Vassar College NY's London Programme with Goldsmith University.
paul.chrystal@btinternet.com

By the Same Author

Hull in 50 Buildings
Hull Pubs
Old Hessle
A-Z York History
A-Z of Leeds: Places-People-History
Pocklington Through Time
Yorkshire Literary Landscapes
Pubs in & Around York
The Place Names of Yorkshire
The Romans in the North of England
Pubs in the Yorkshire Dales
Yorkshire Murders, Manslaughter, Madness & Executions